ABSTRACTS & ANGELS

BOOK #3

AWESOME ABSTRACTS

Enjoy distinctive abstract drawings with the many angels waiting to be found in both the drawings and in life.

Copyright 2019 by Carol Lyons/Abstracts & Angels

All rights reserved. This book or any portion thereof may not be reproduced or used in any manner whatsoever without the express written permission of the publisher, with the exception of sharing colored/finished pages online.

For more information please contact: <u>carolannl2004@gmail.com</u>

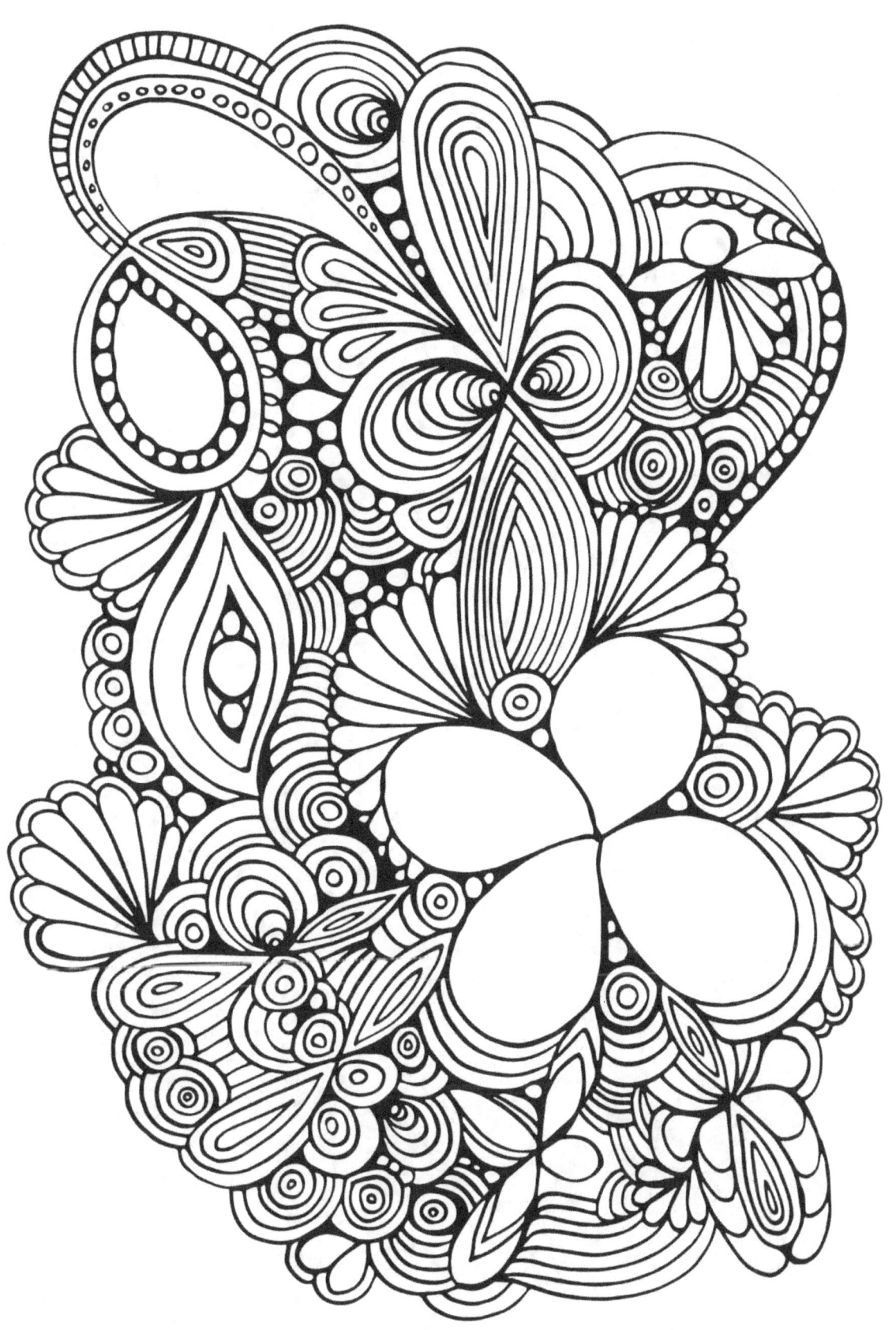

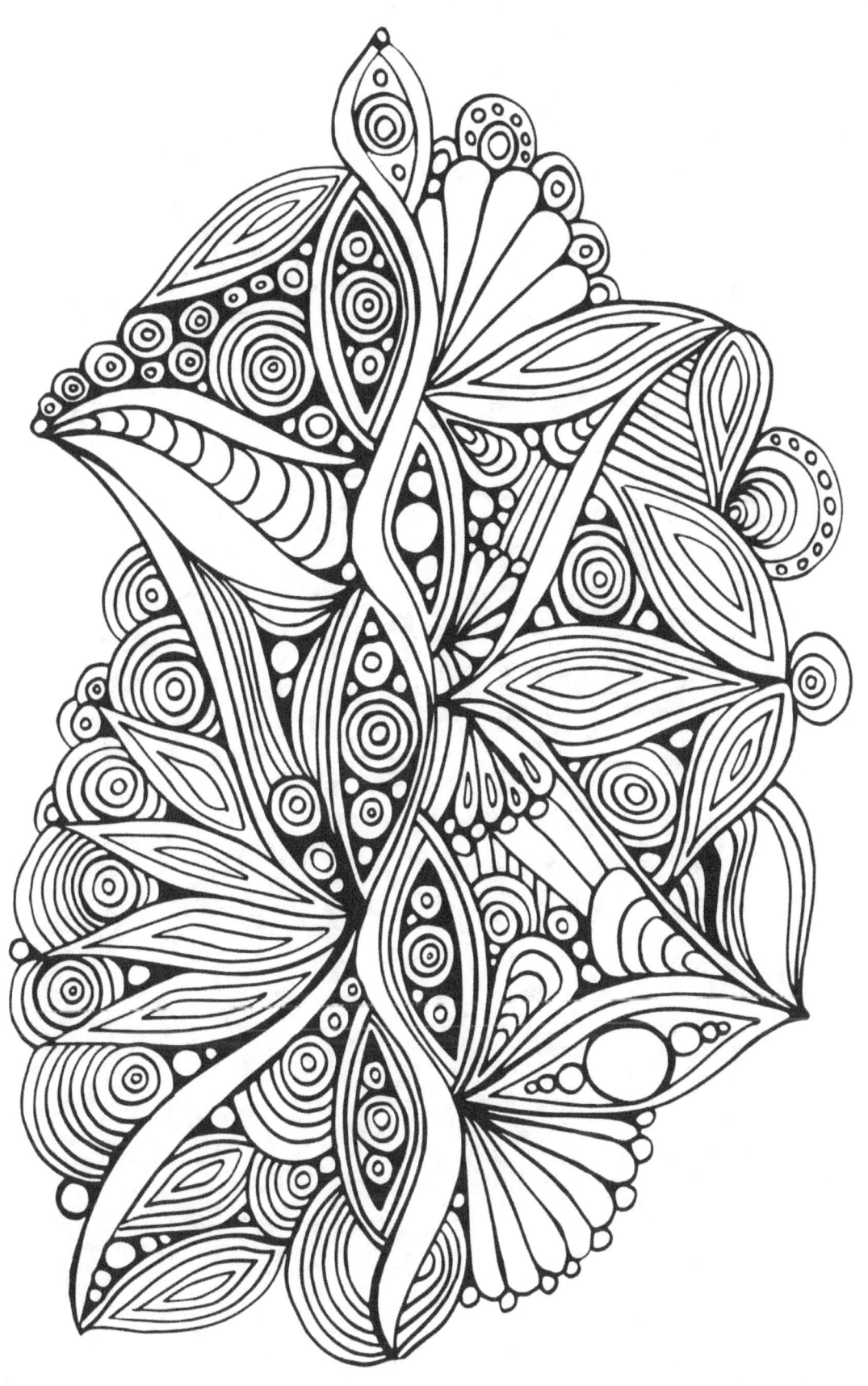

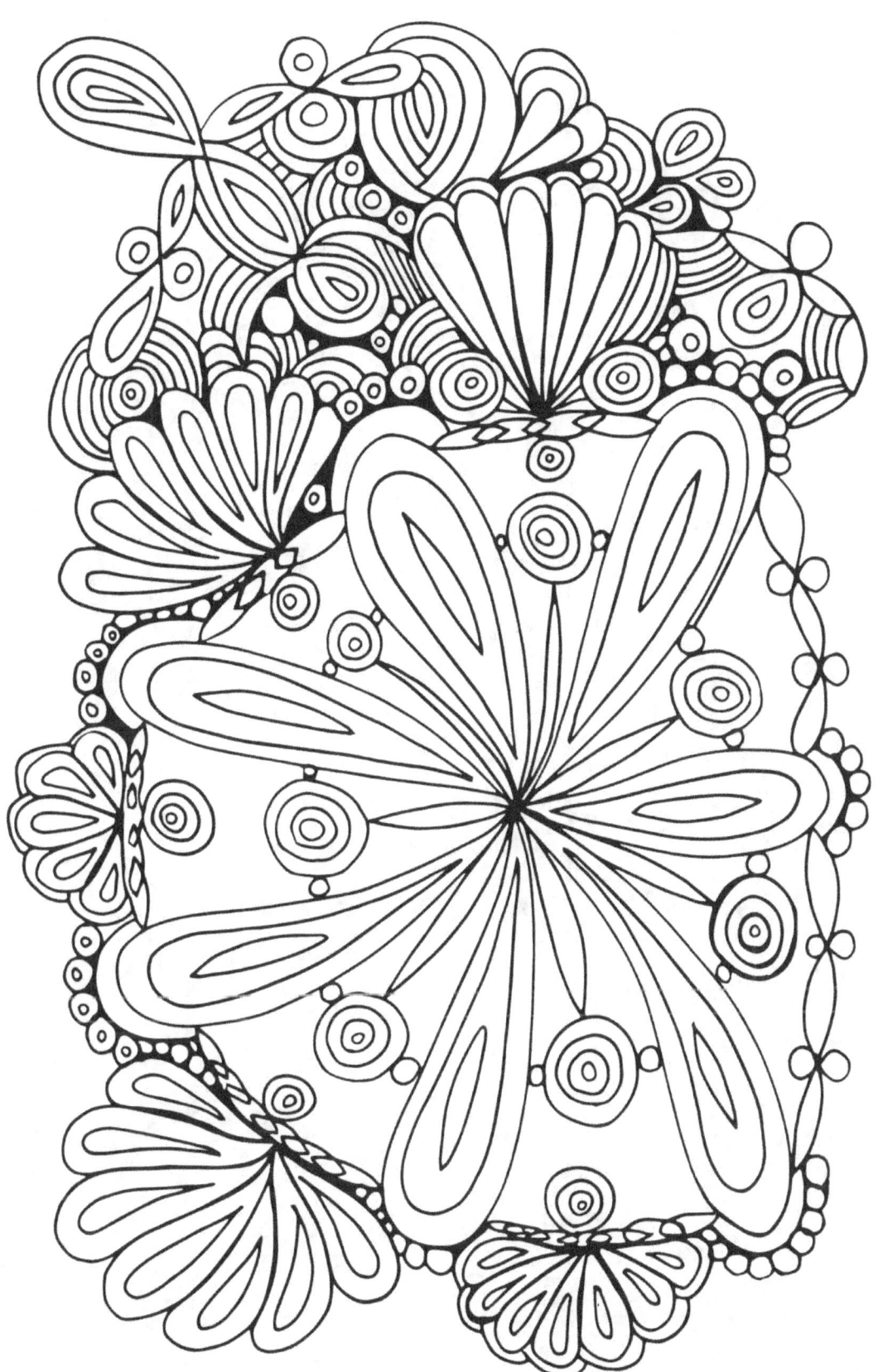

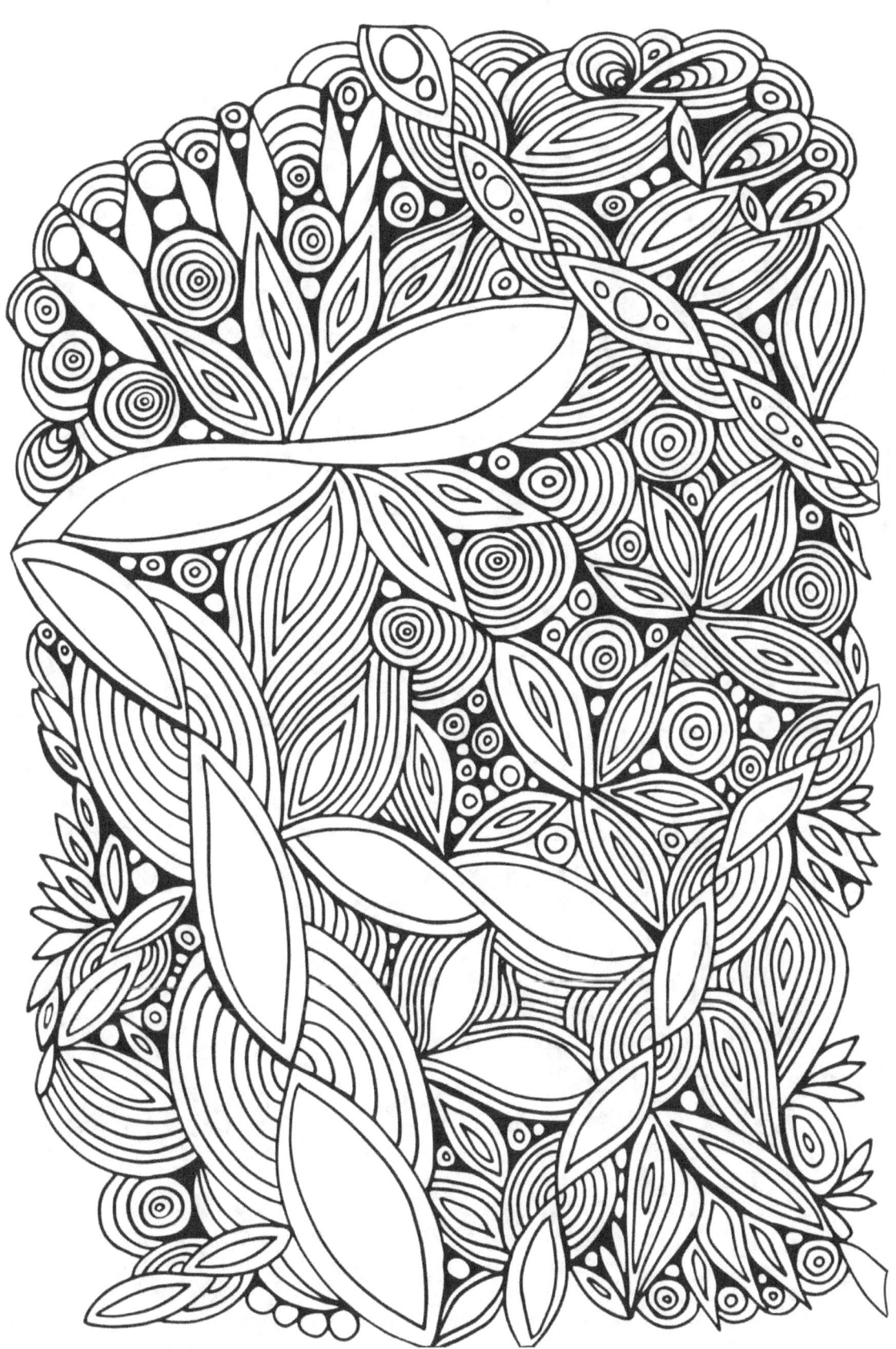

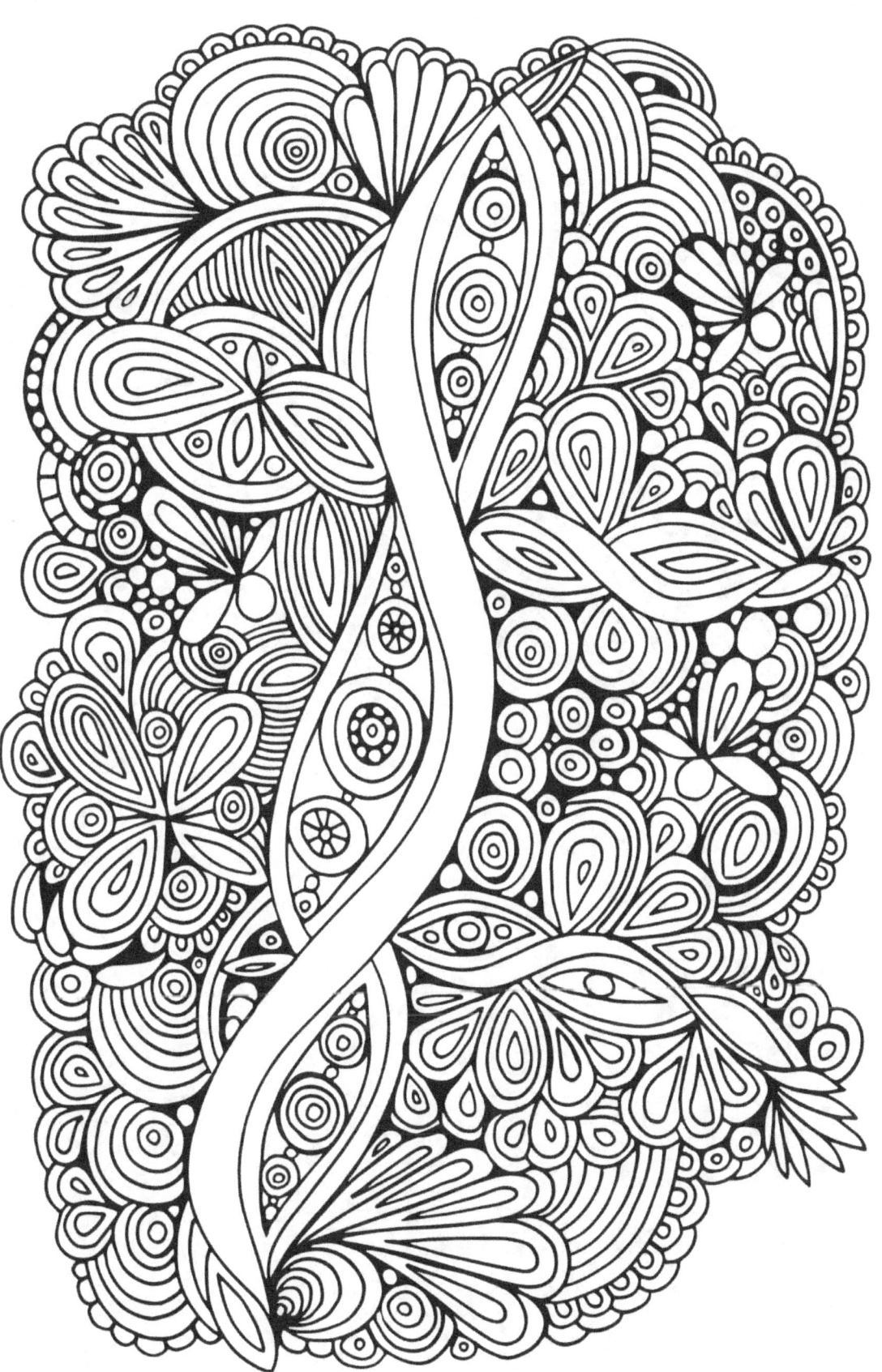

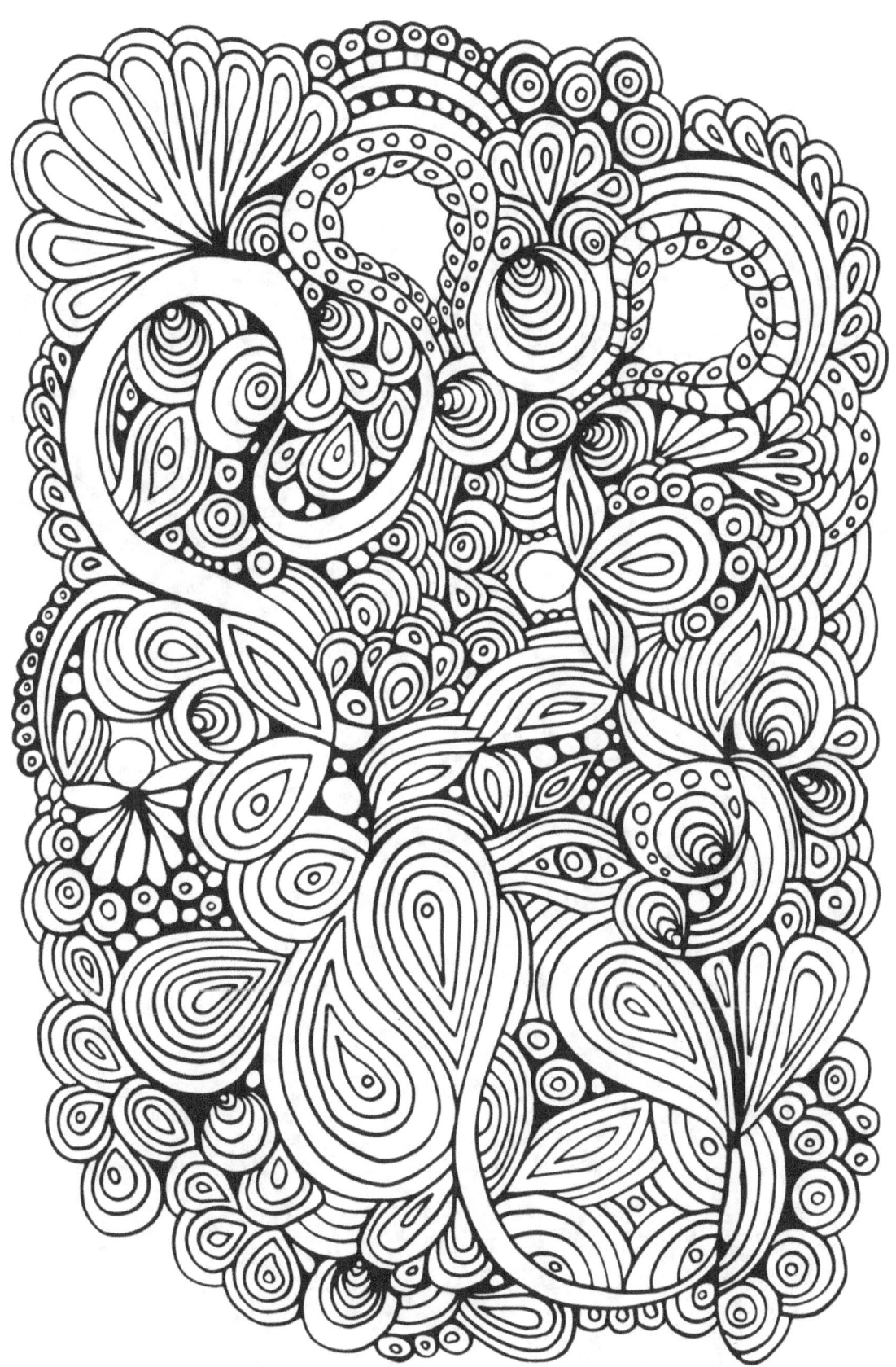

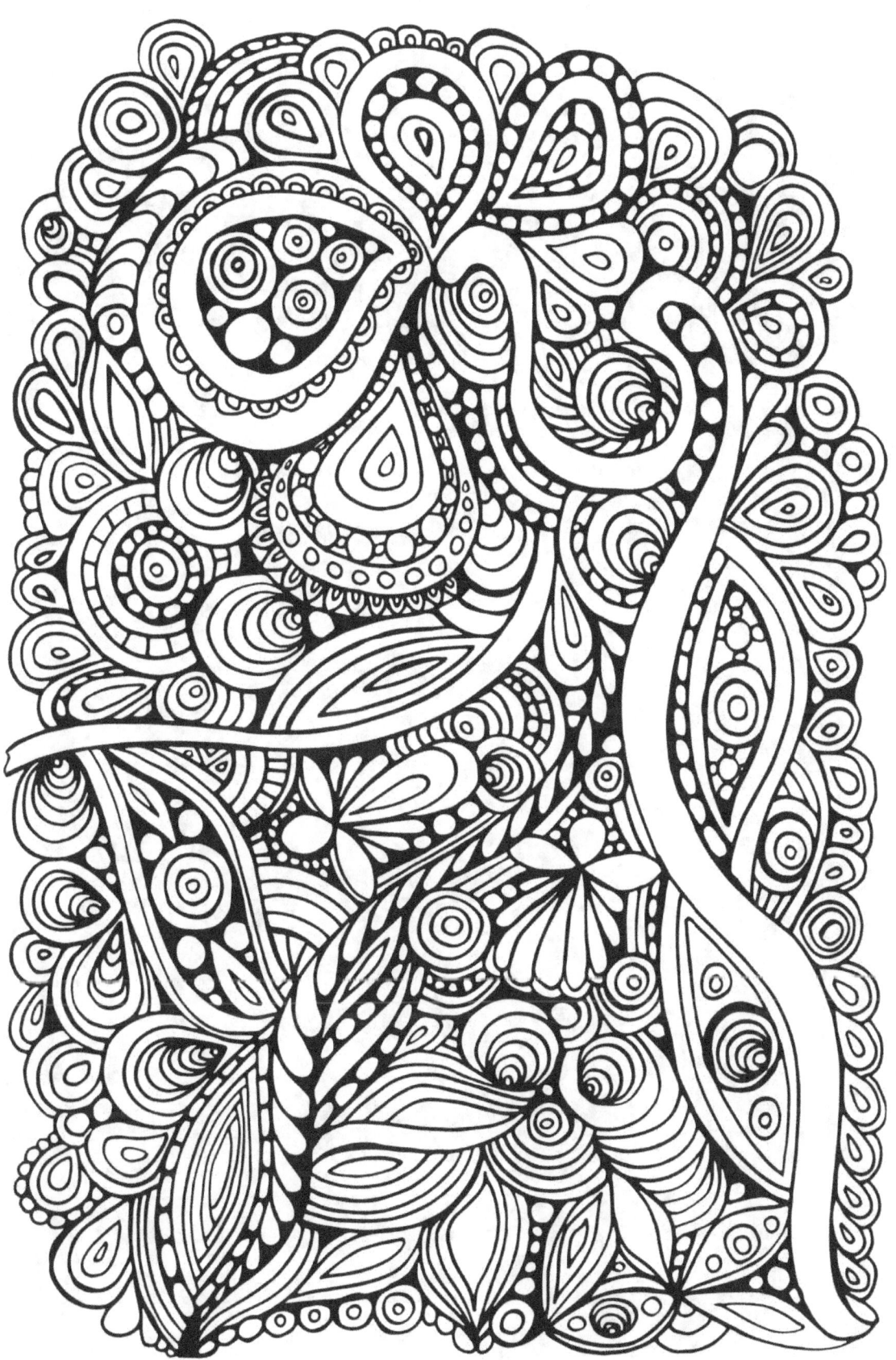

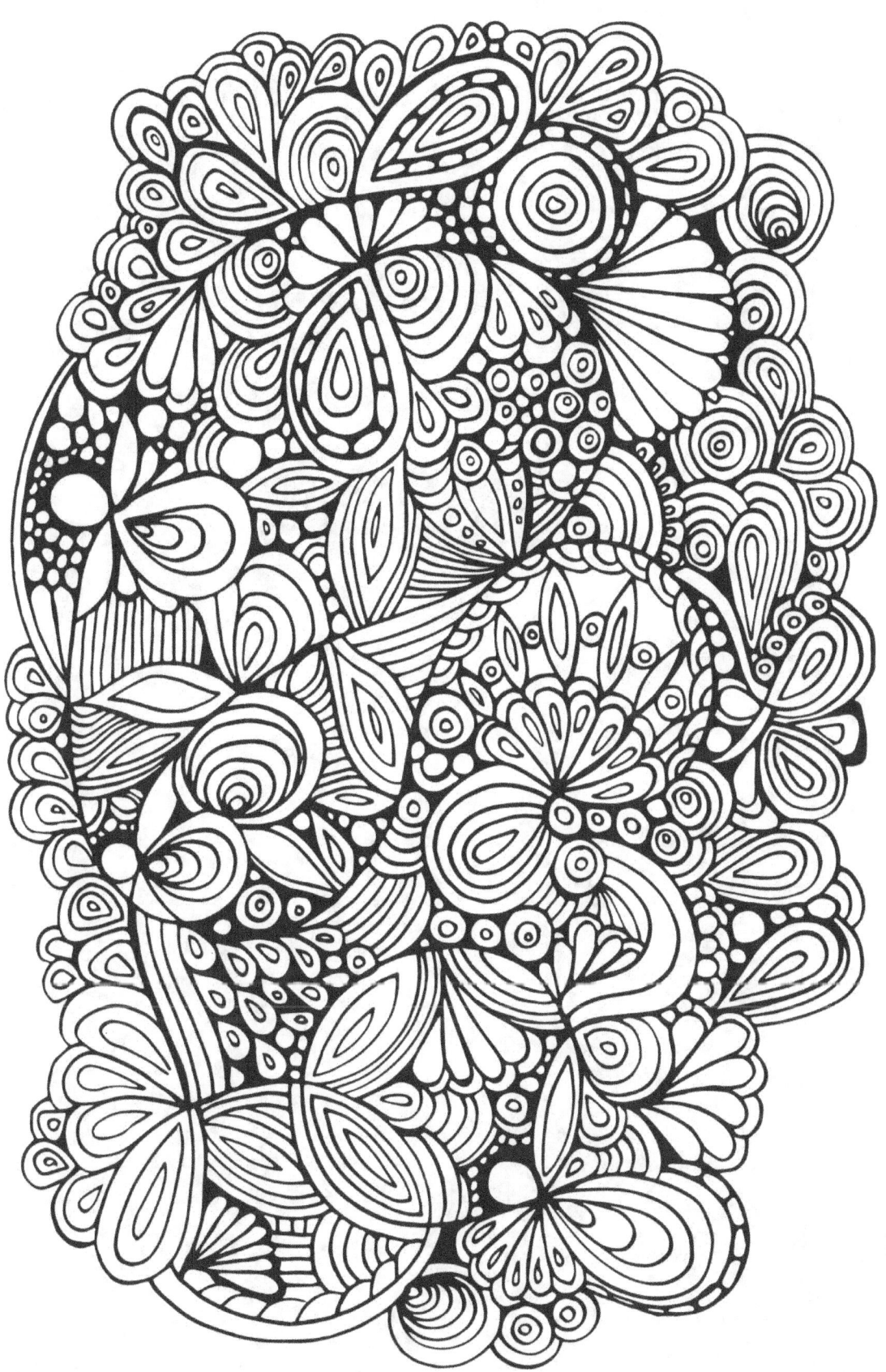

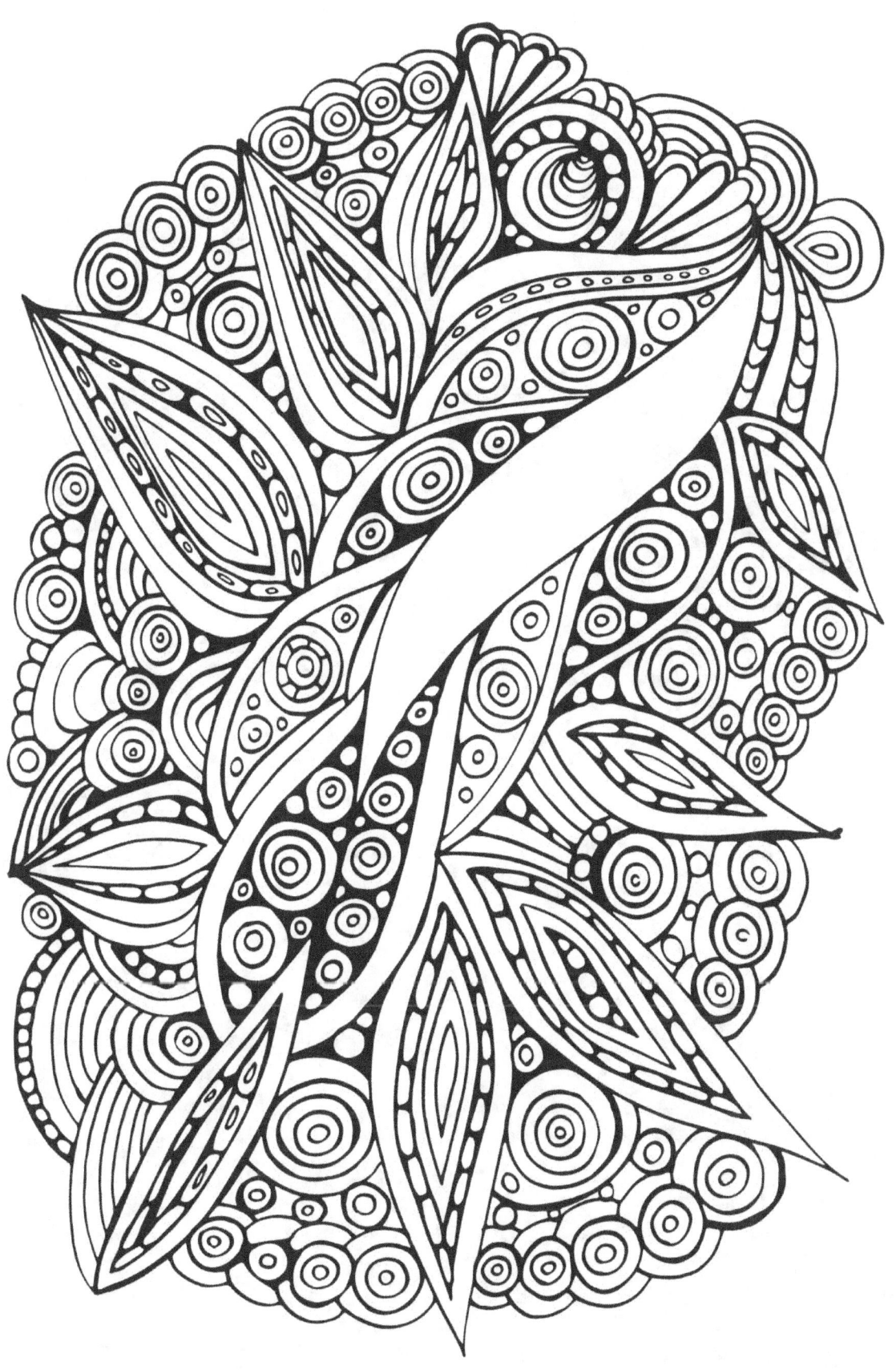

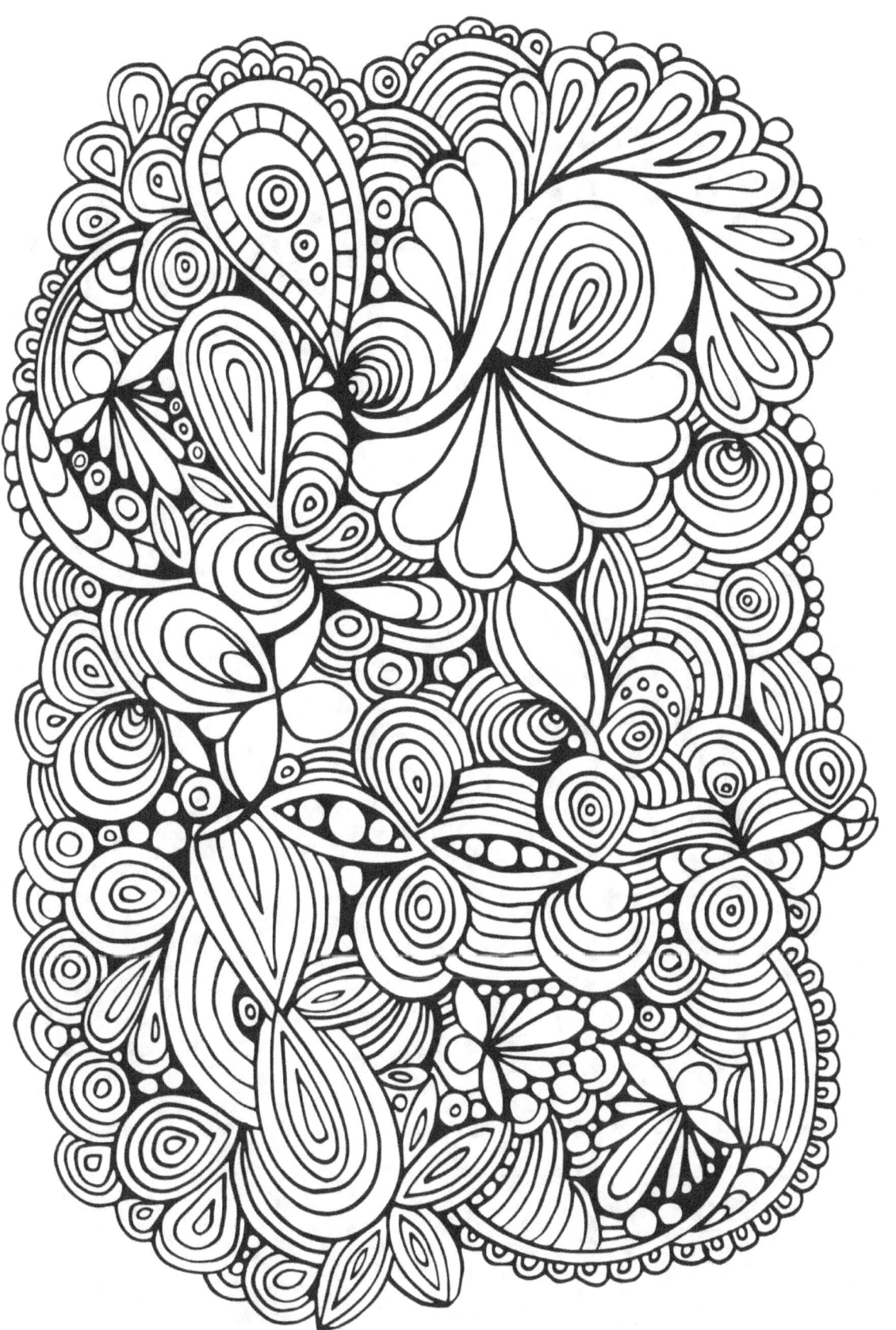

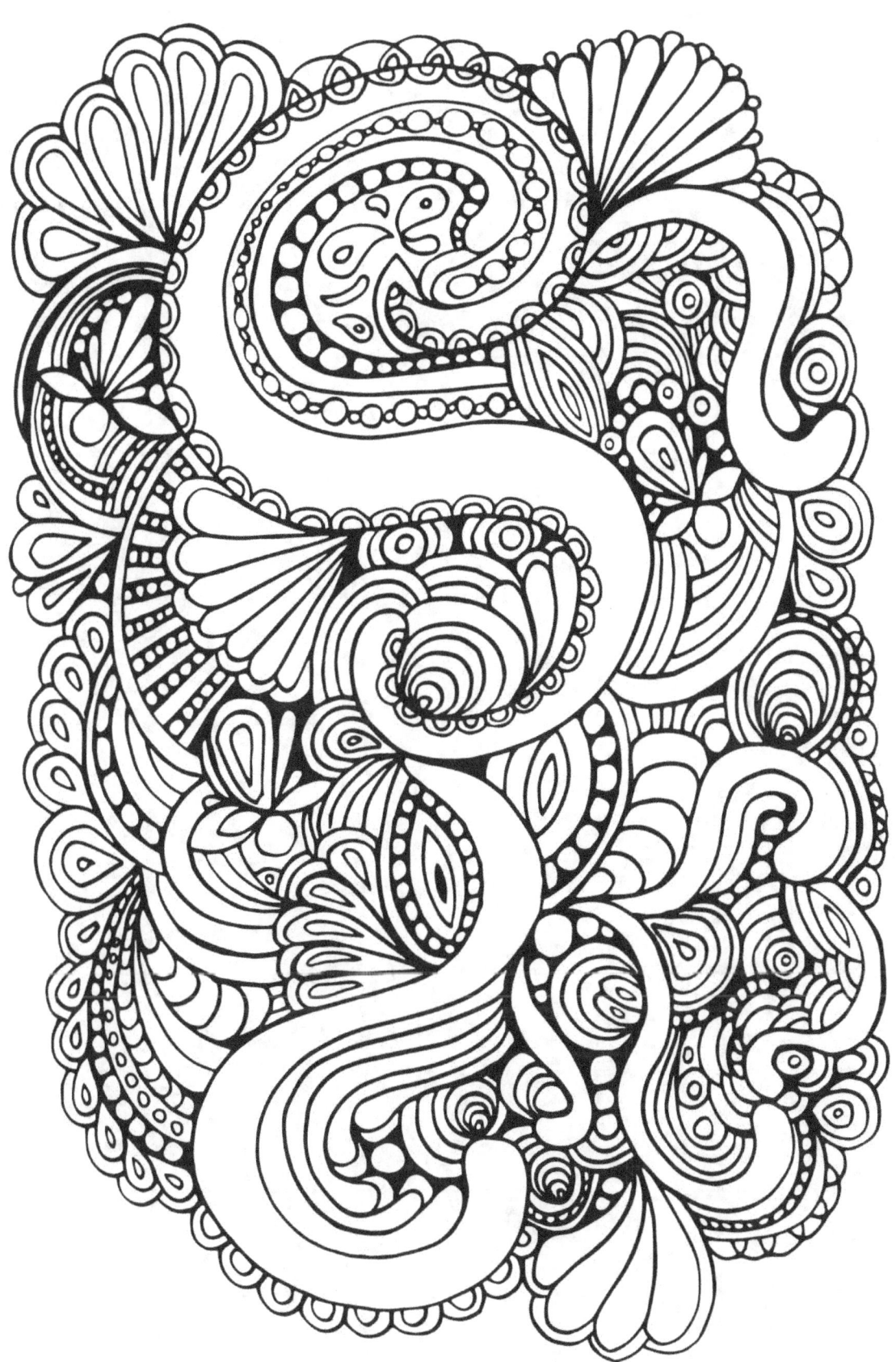

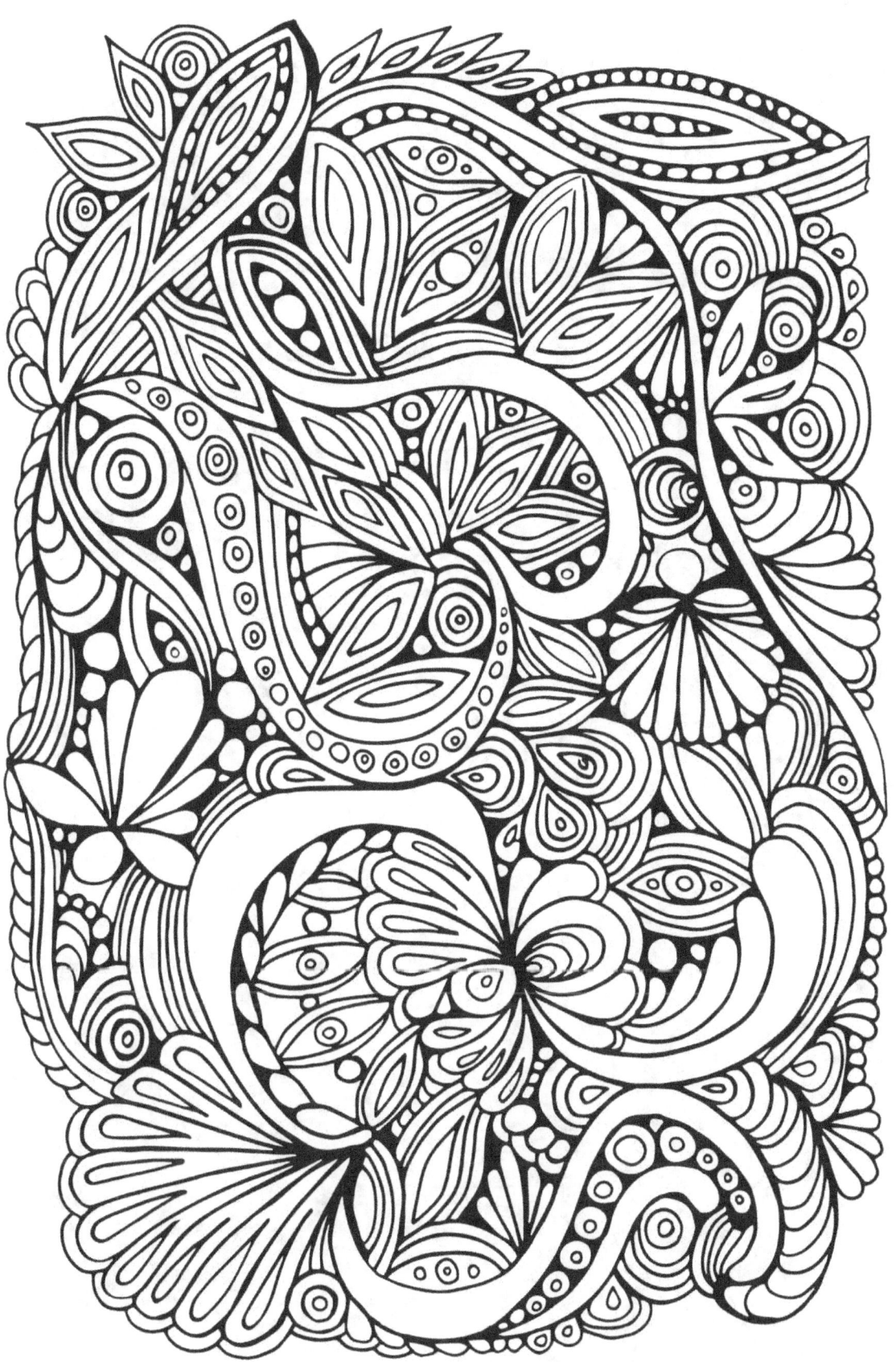

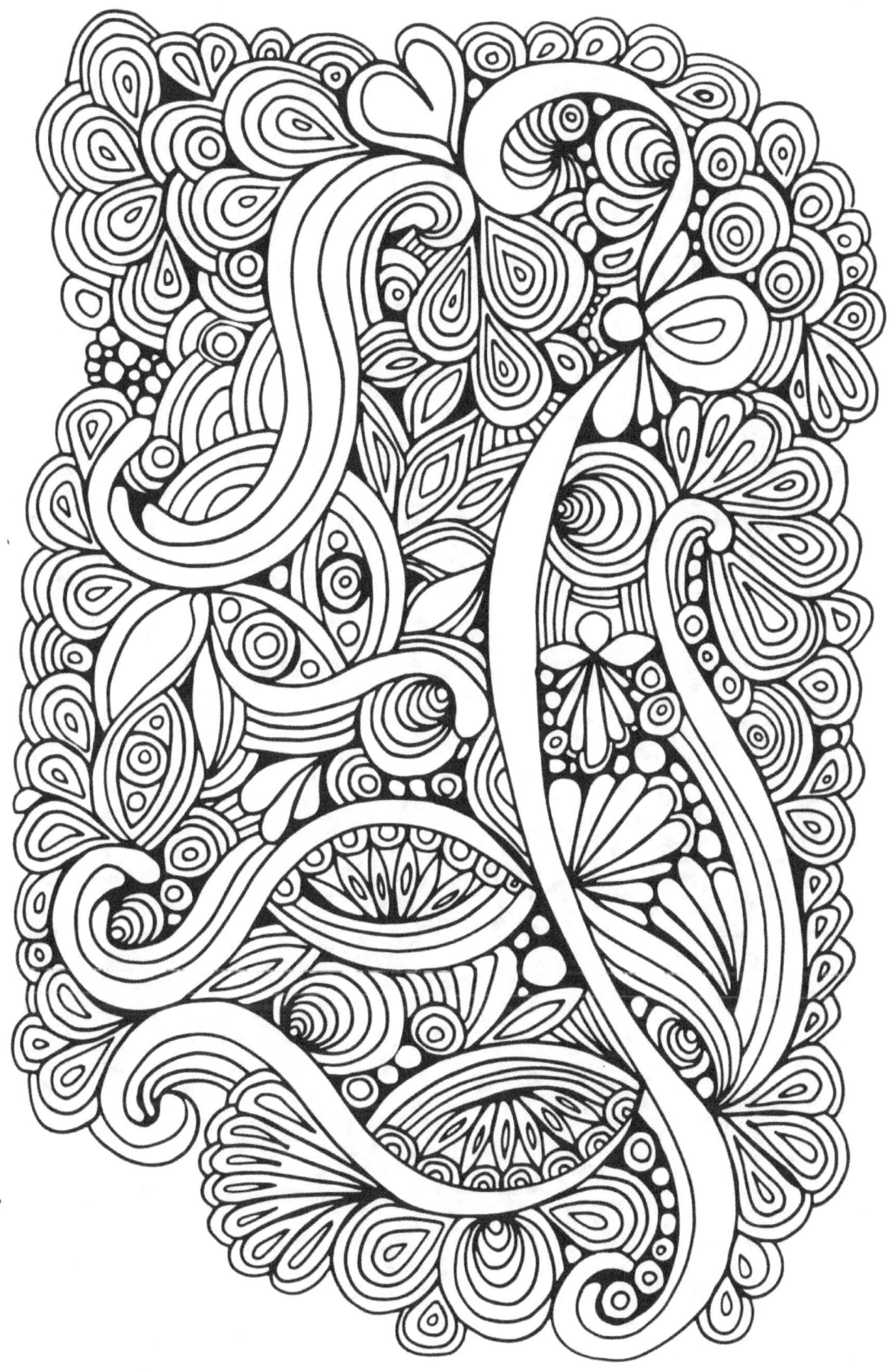

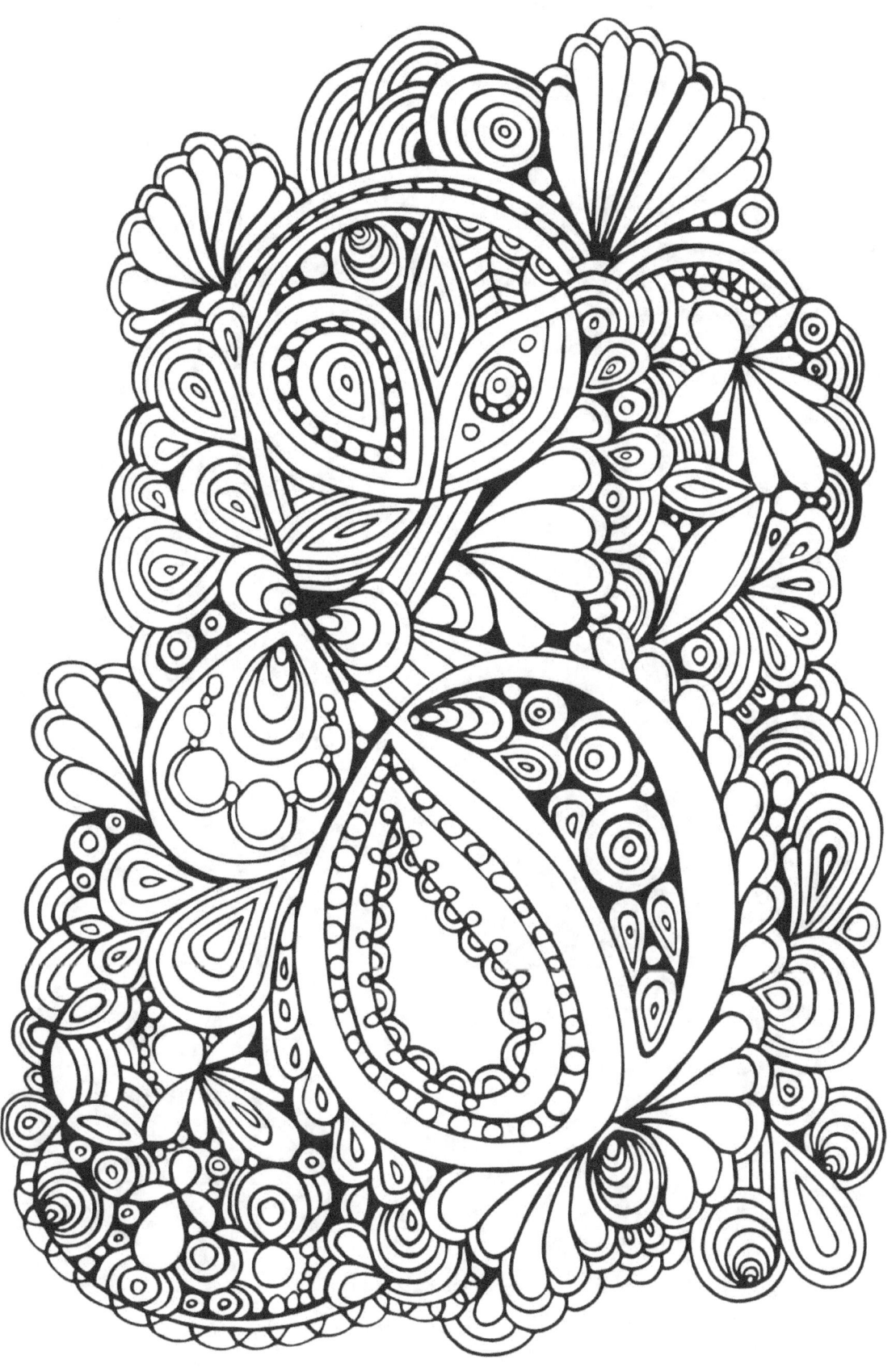

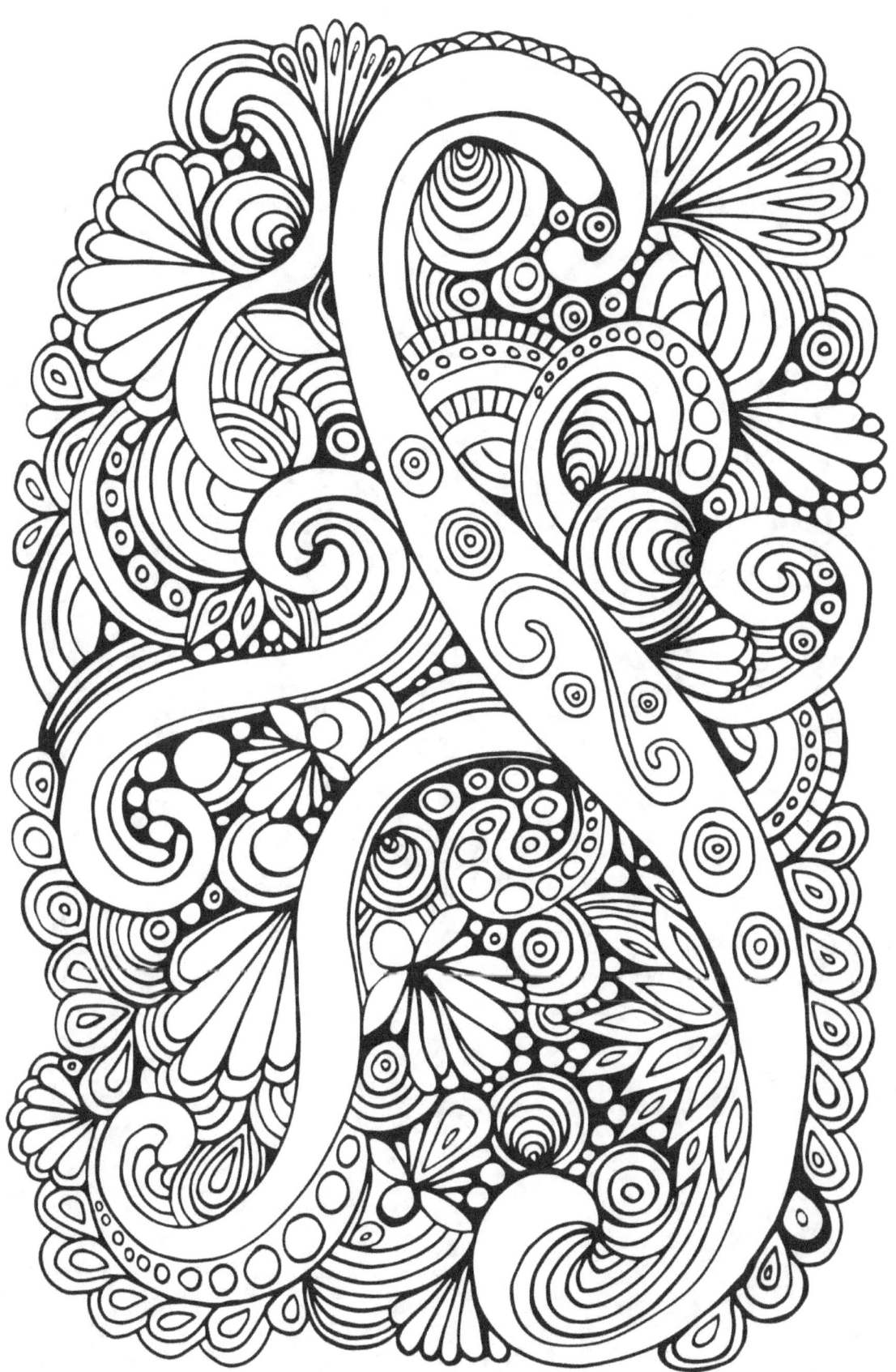

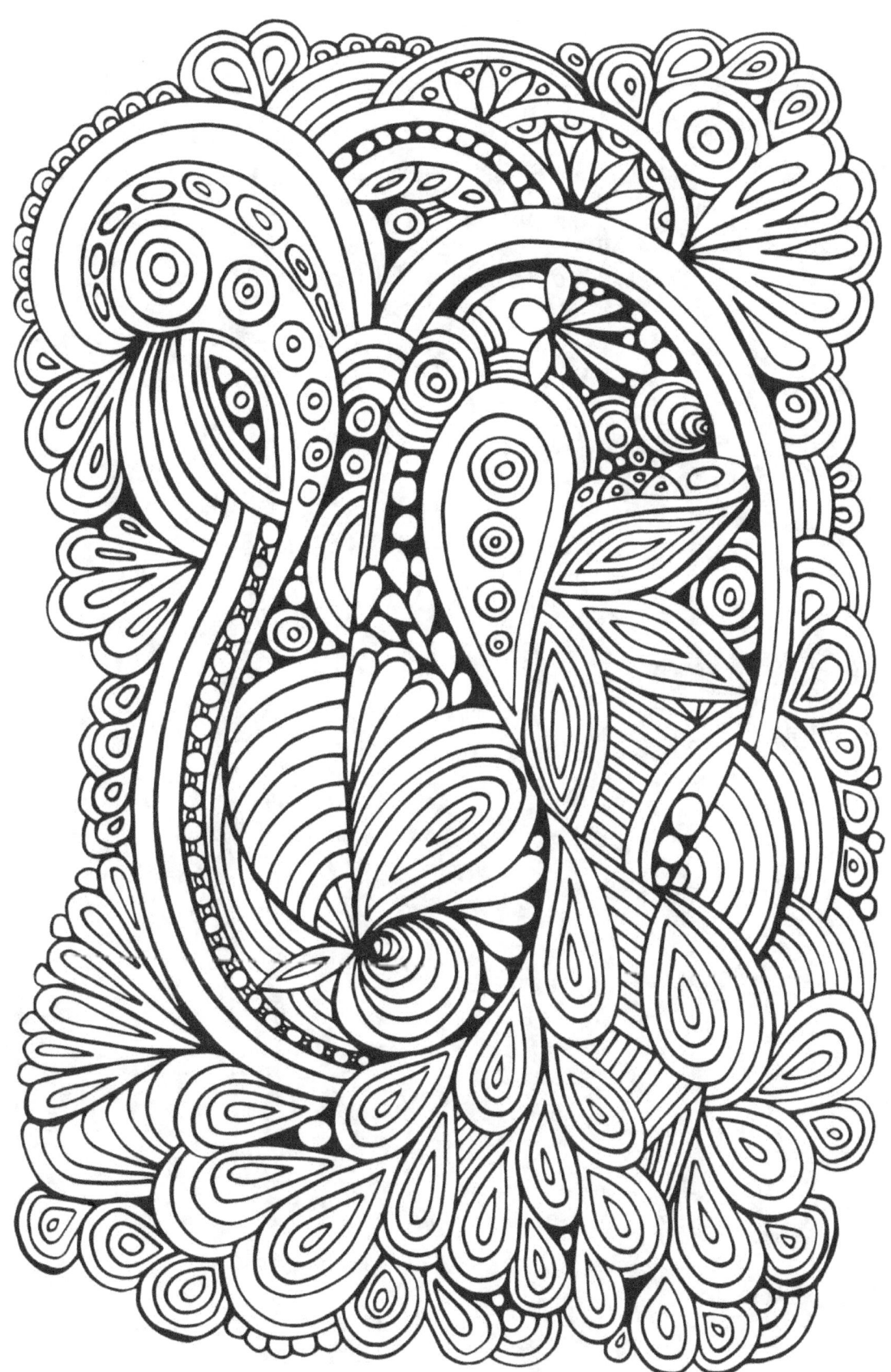

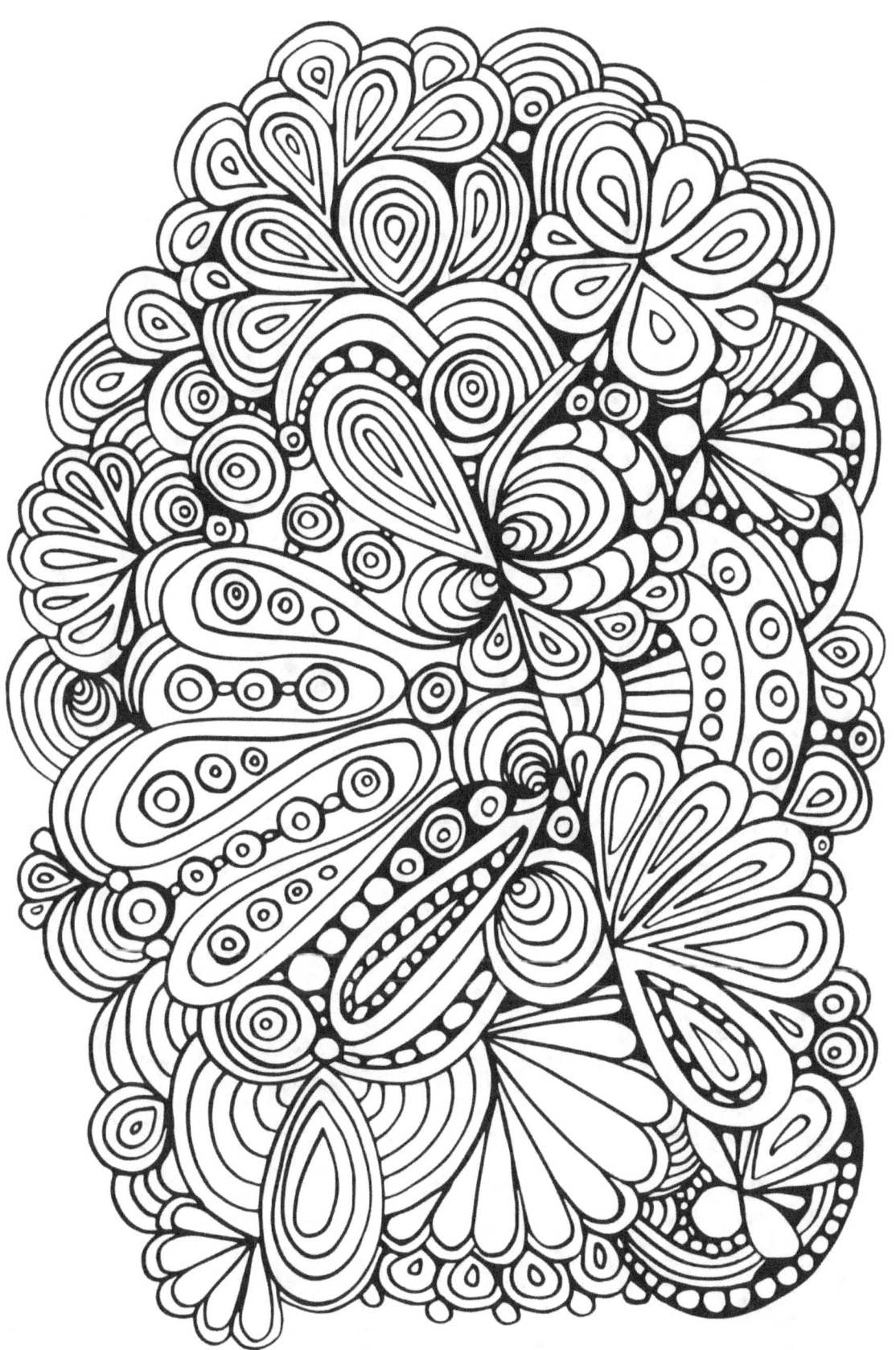

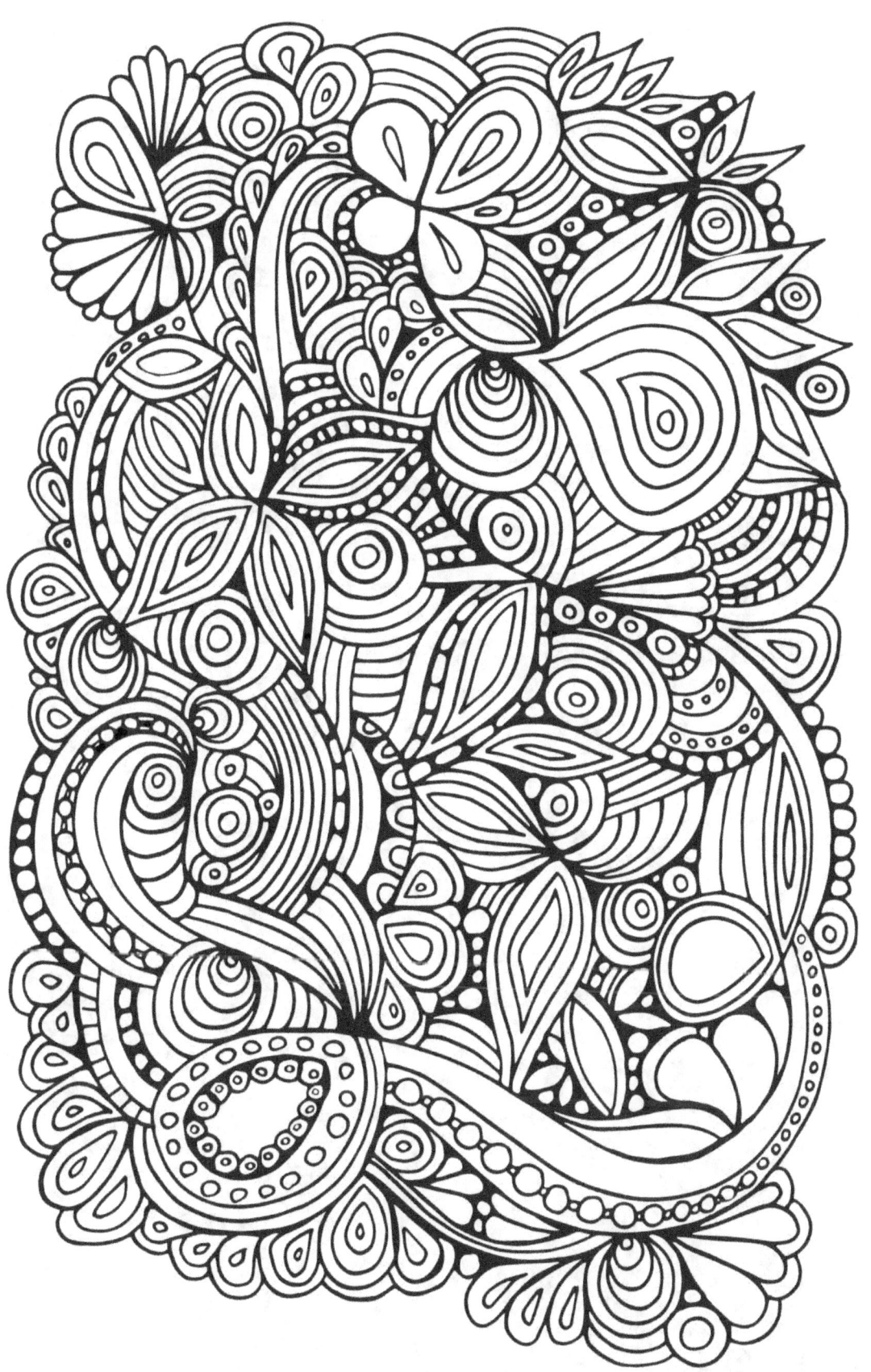

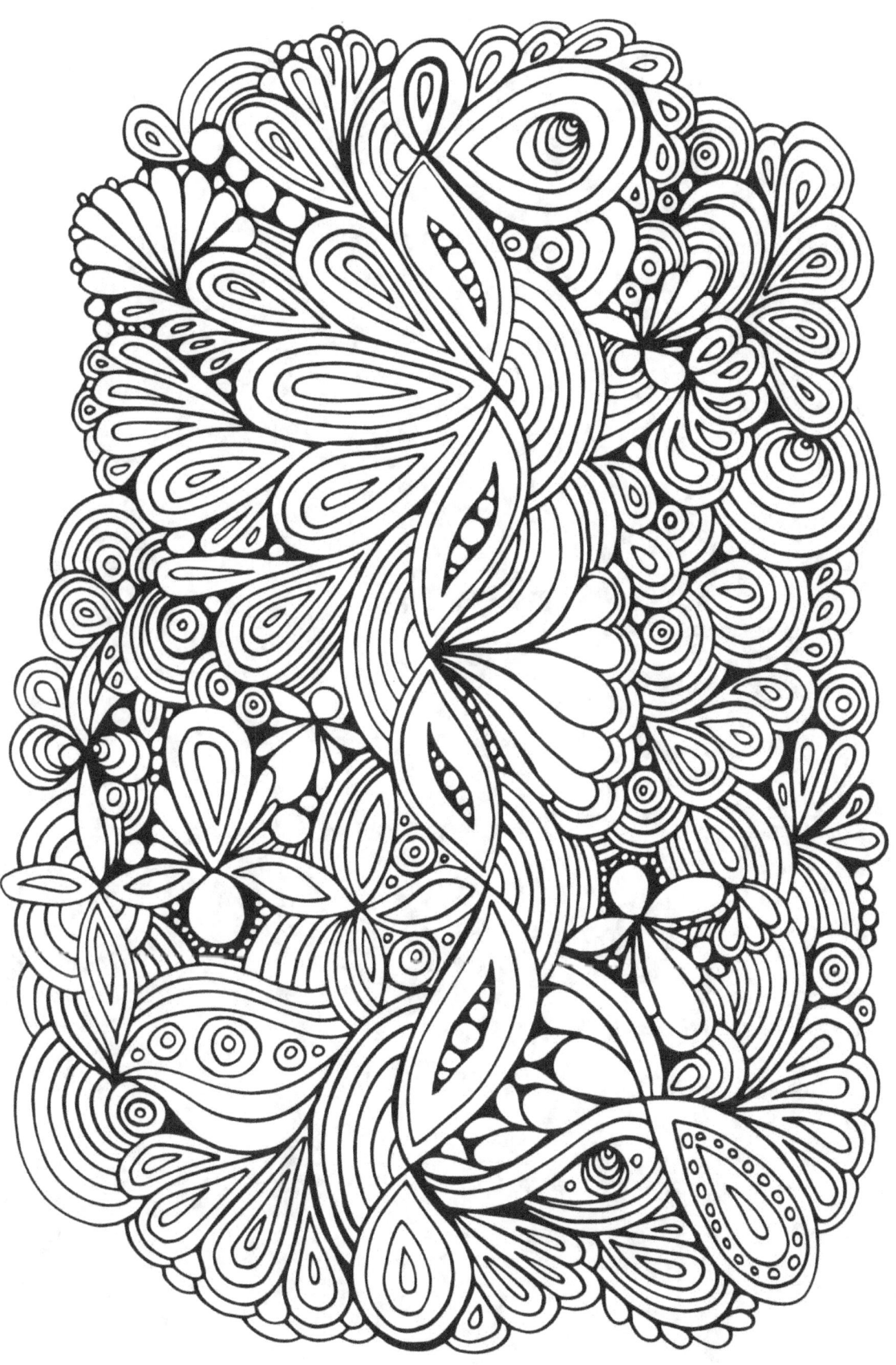

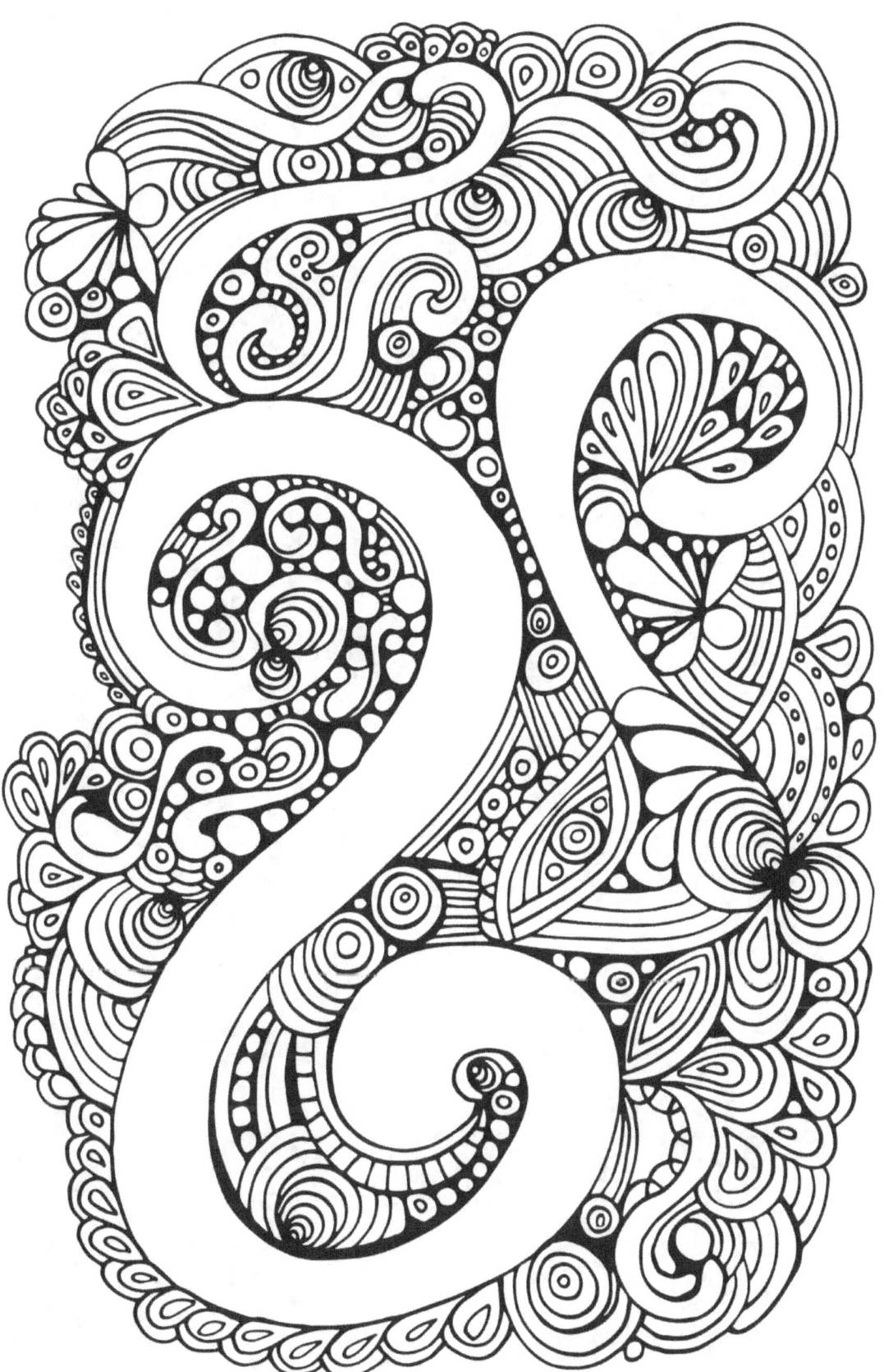

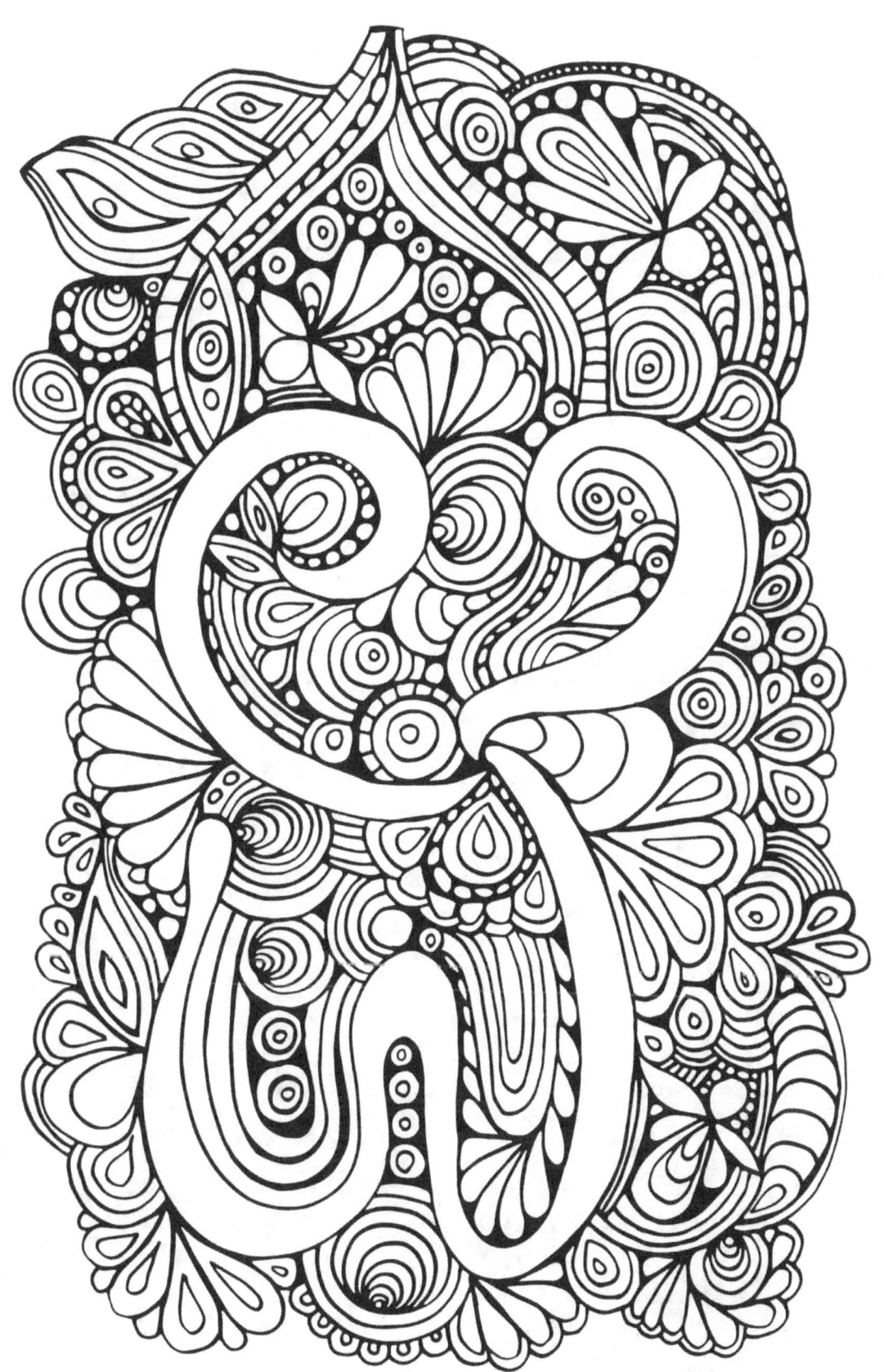

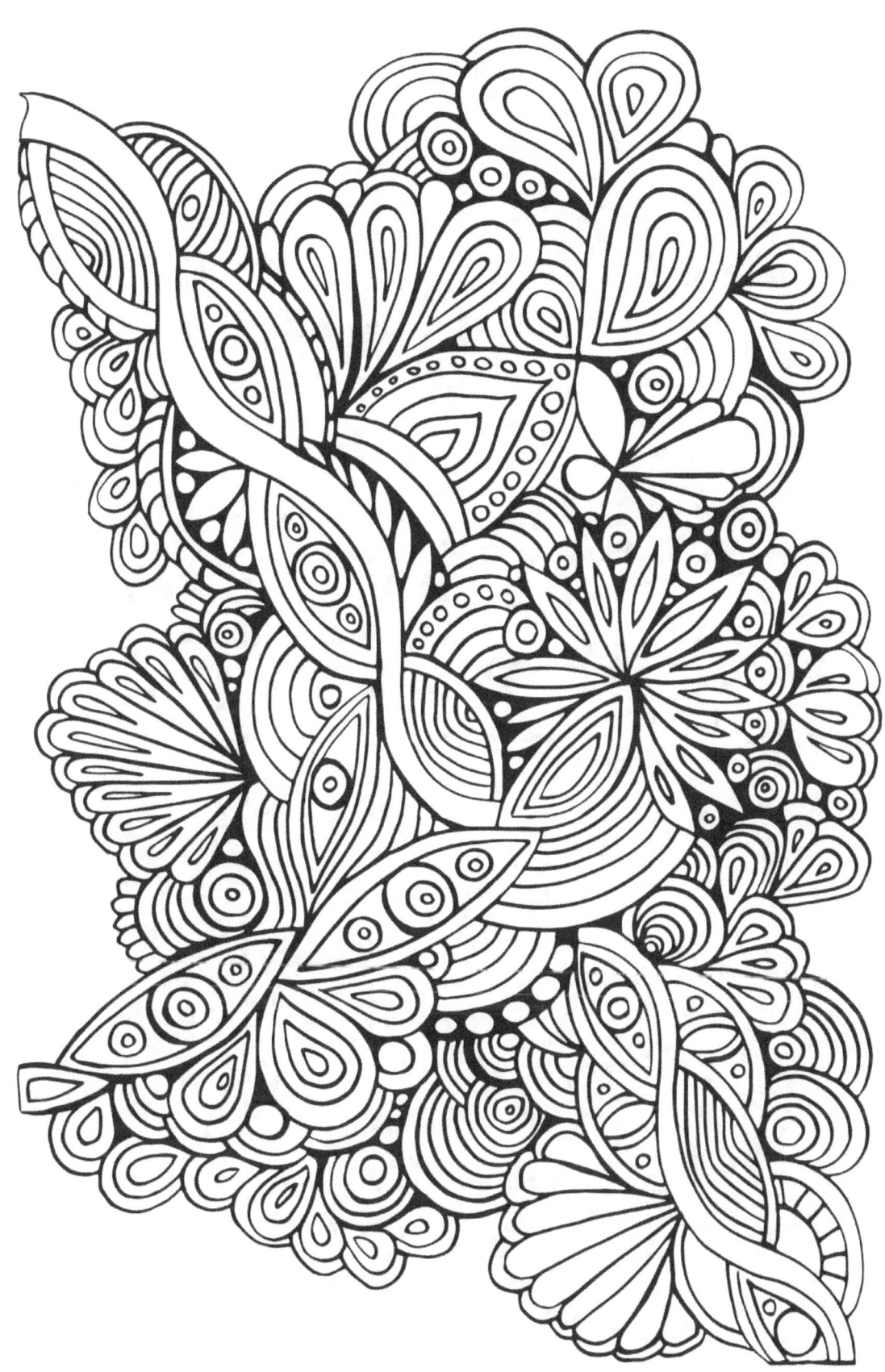

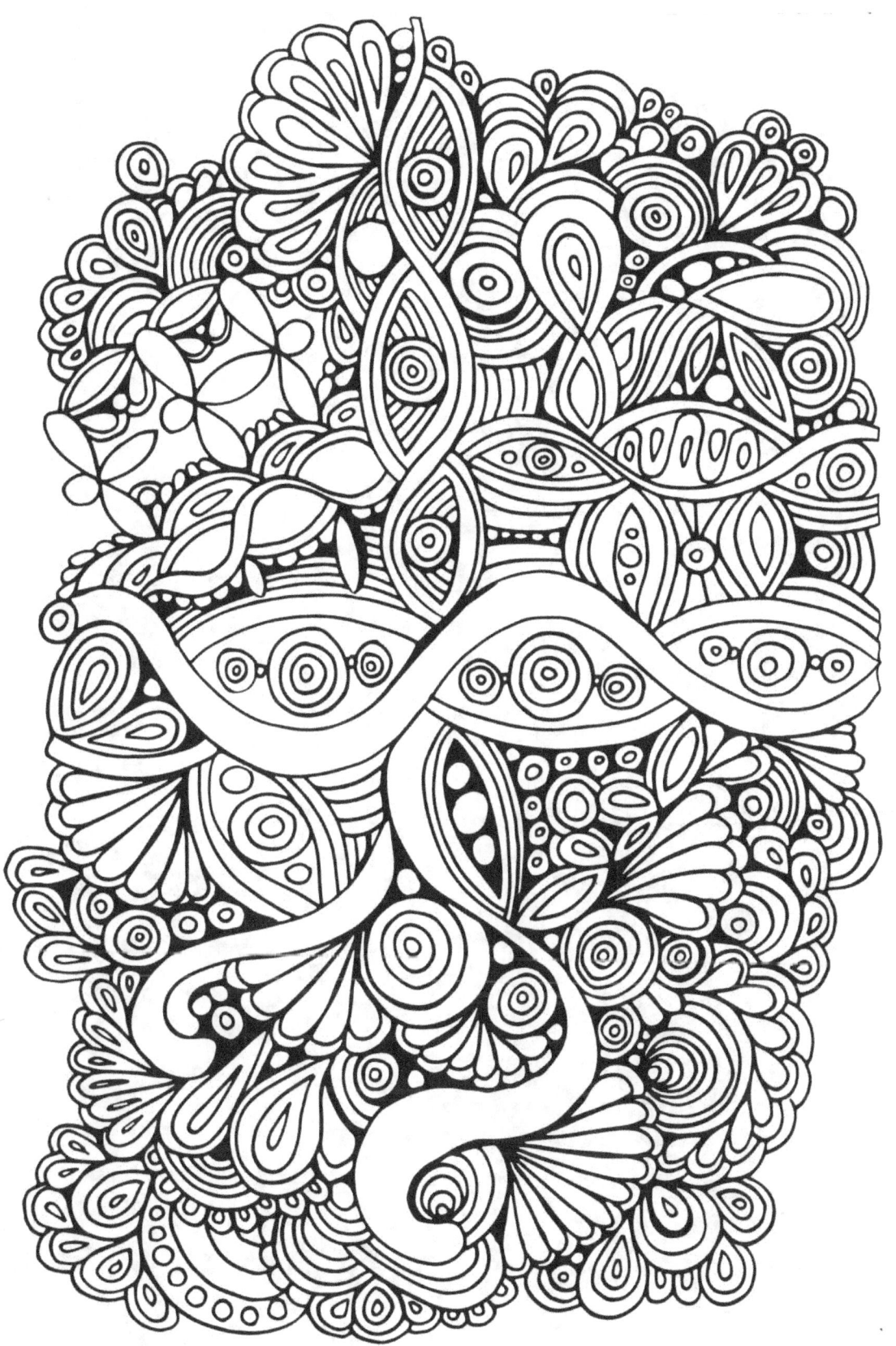

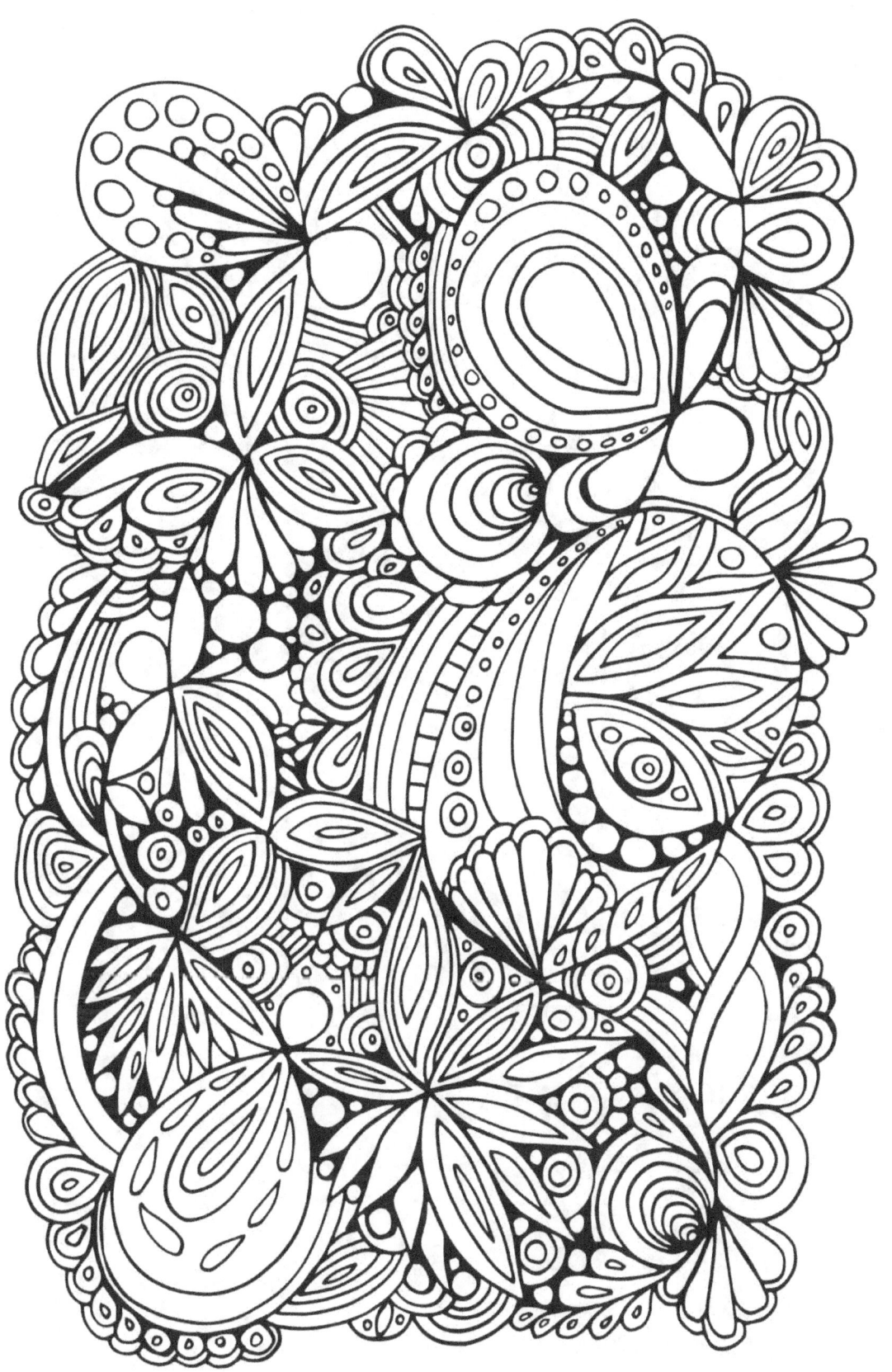

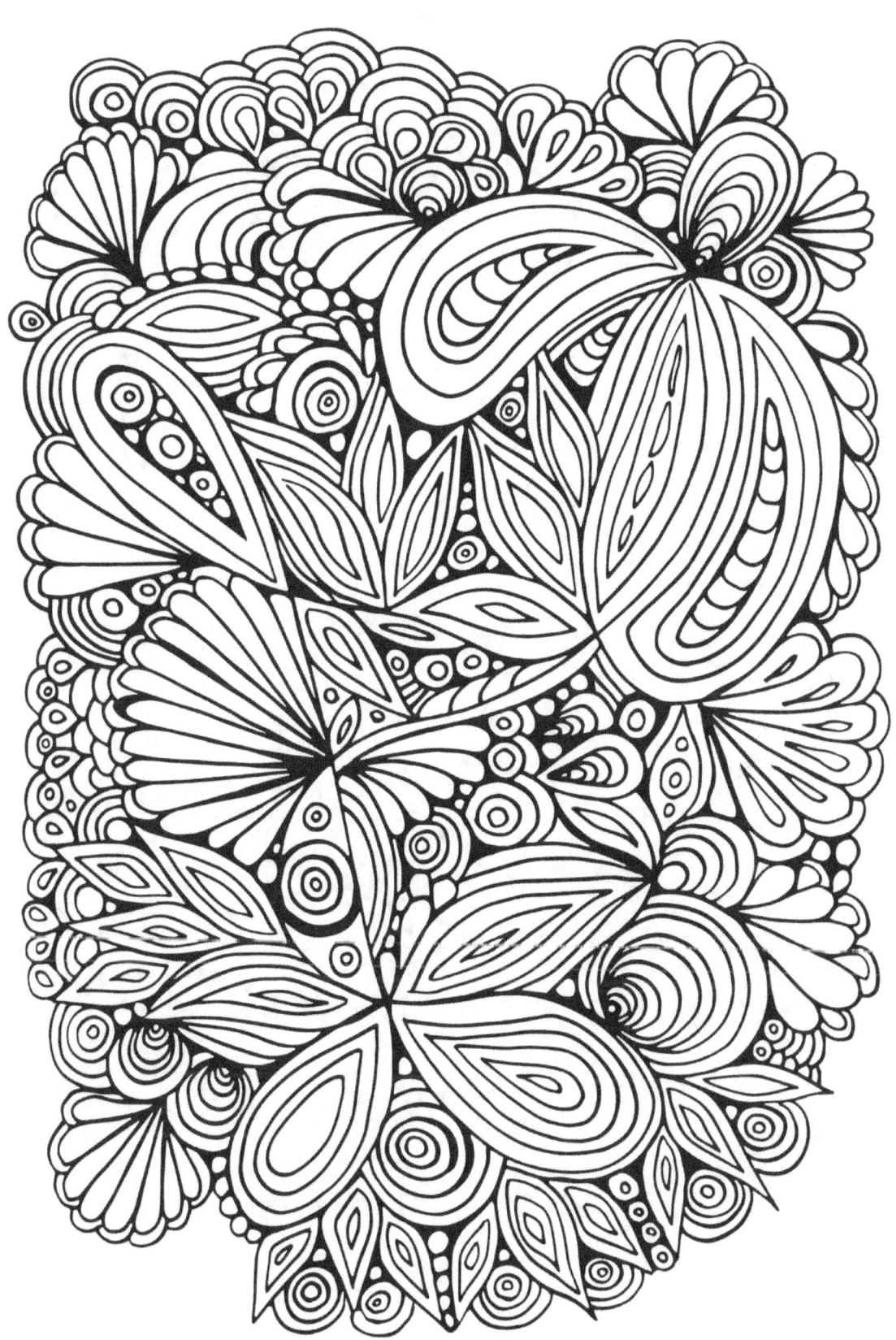

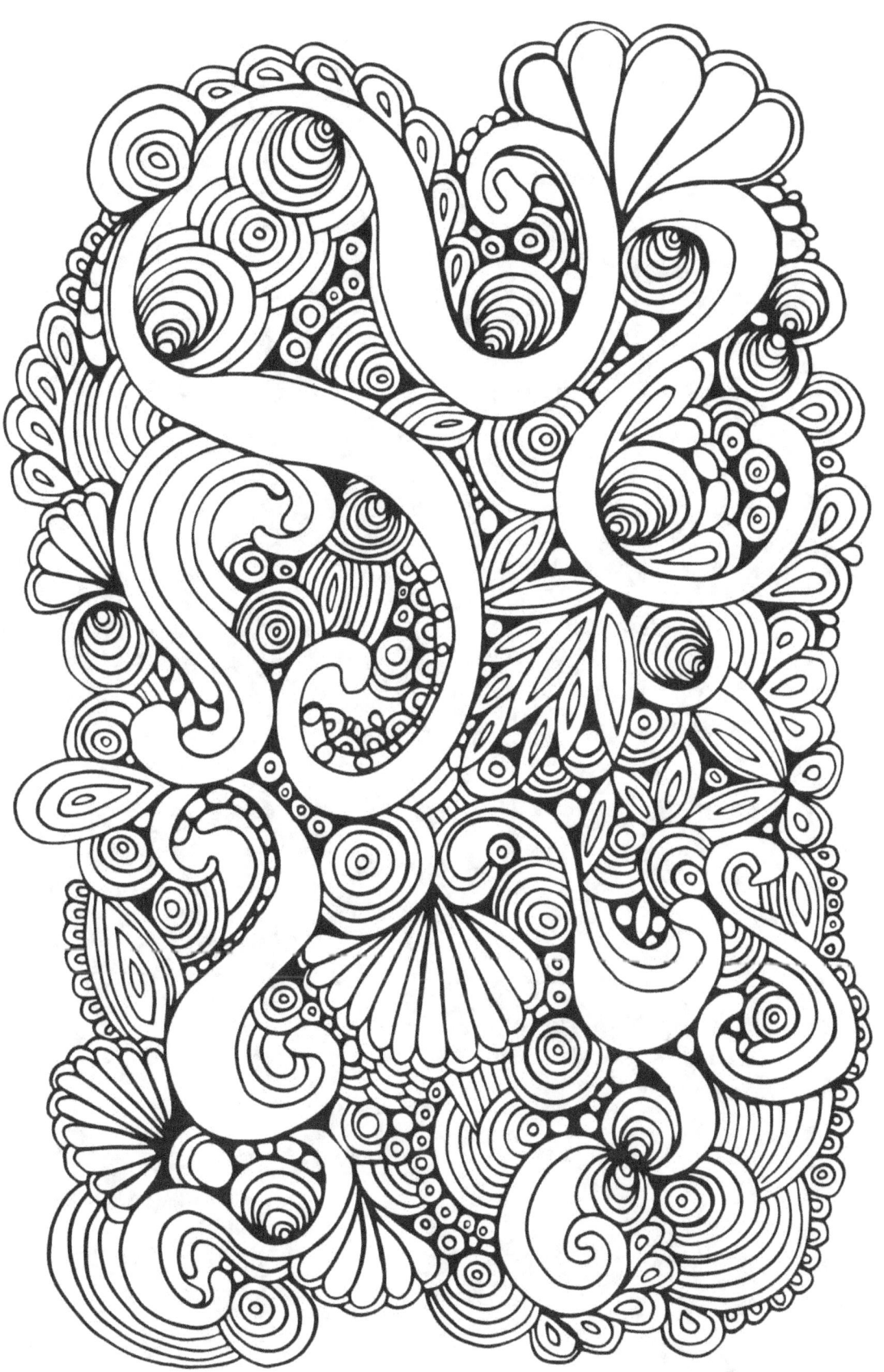

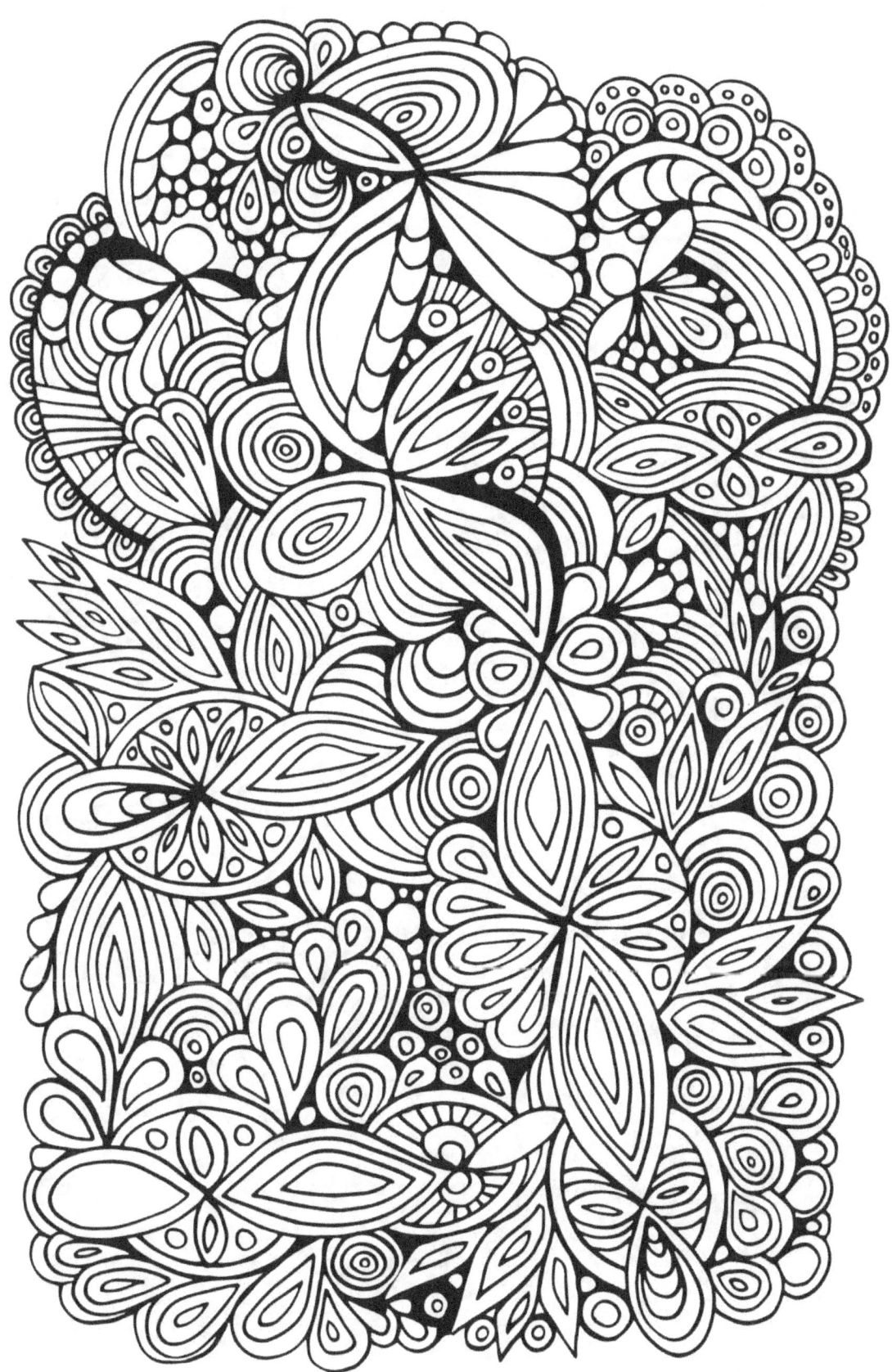

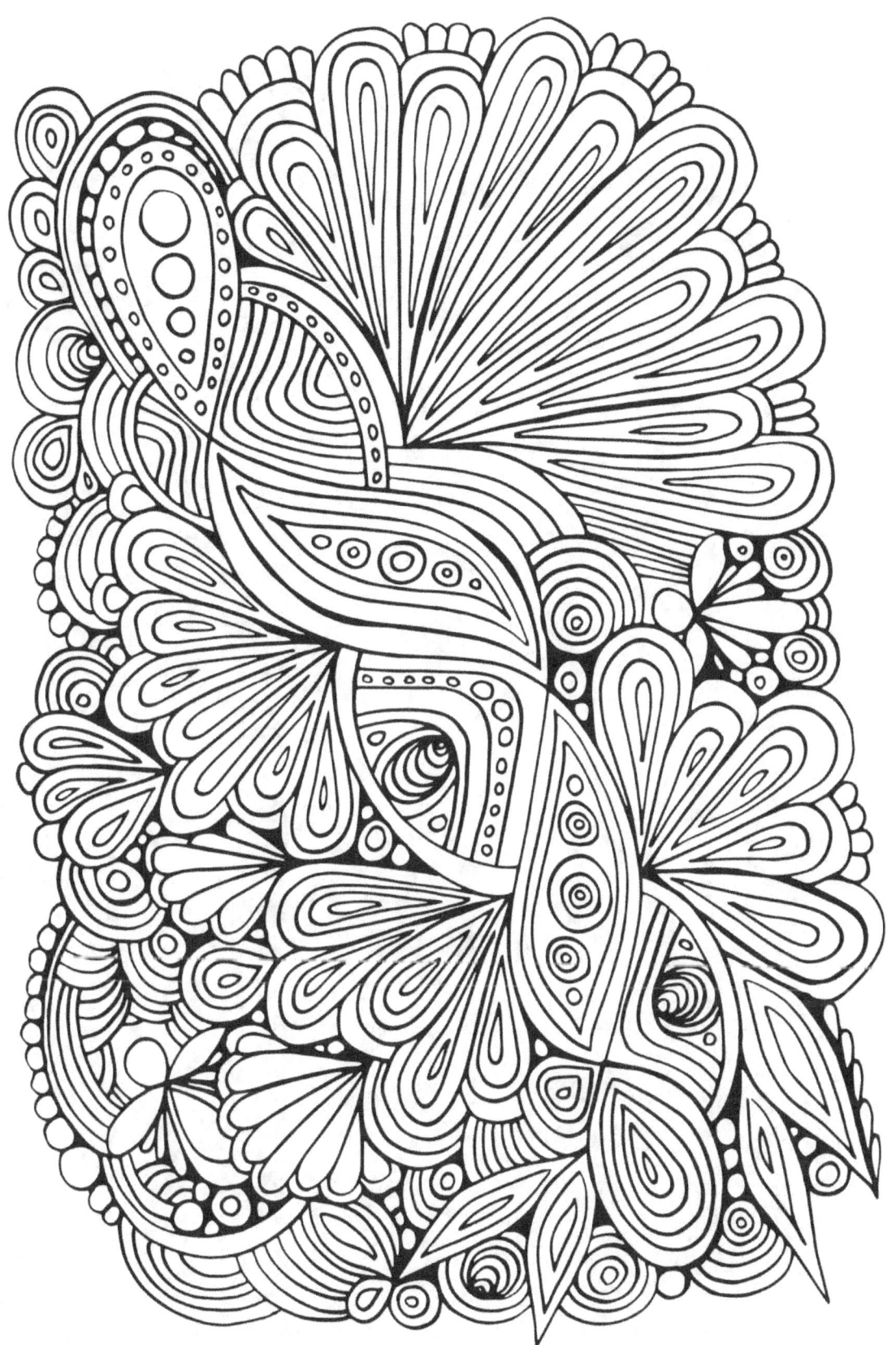

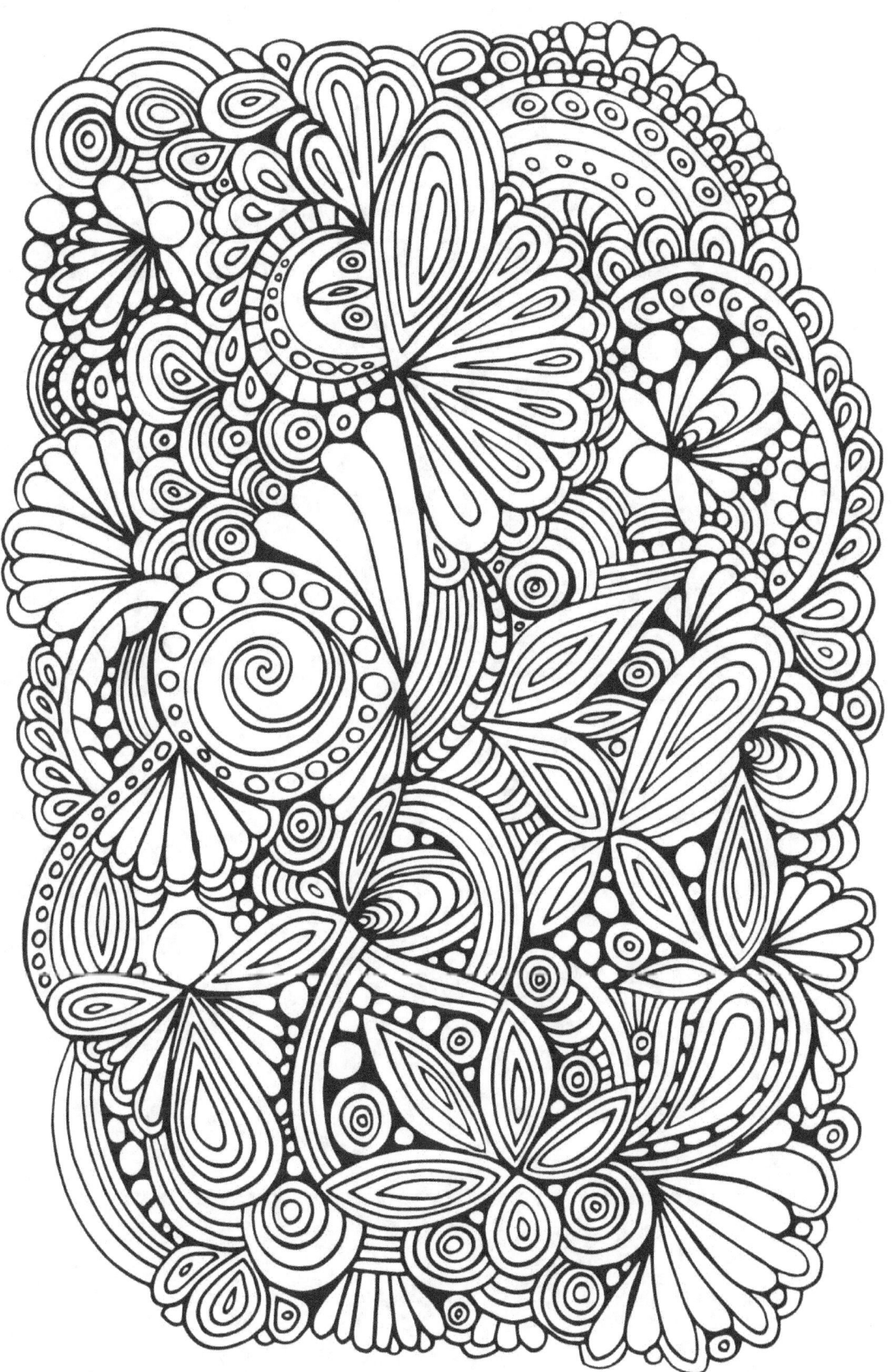

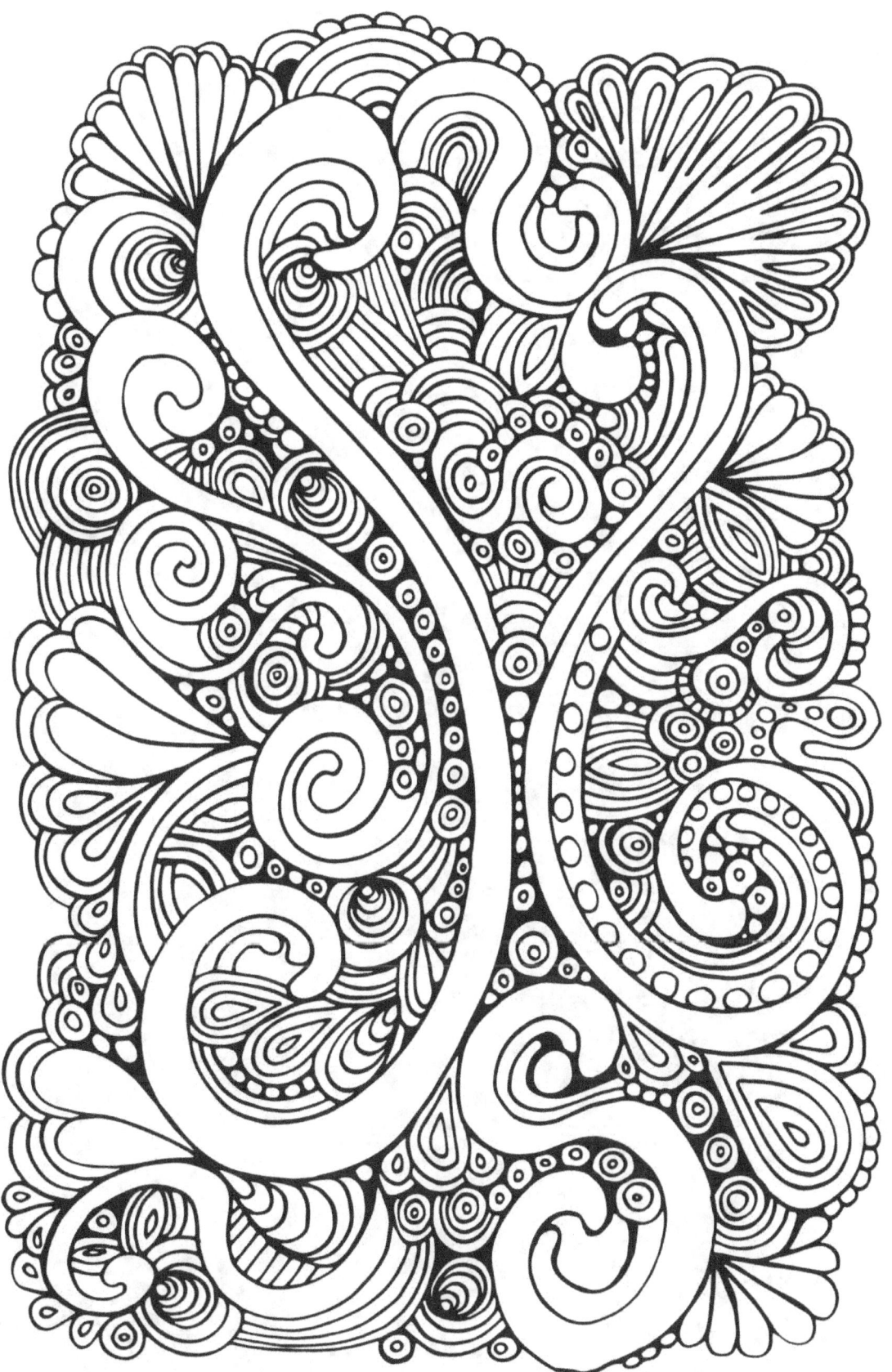

www.ingramcontent.com/pod-product-compliance
Lightning Source LLC
Chambersburg PA
CBHW081551220526
45468CB00014B/2913